D0745517

HAND LETTERING TODAY

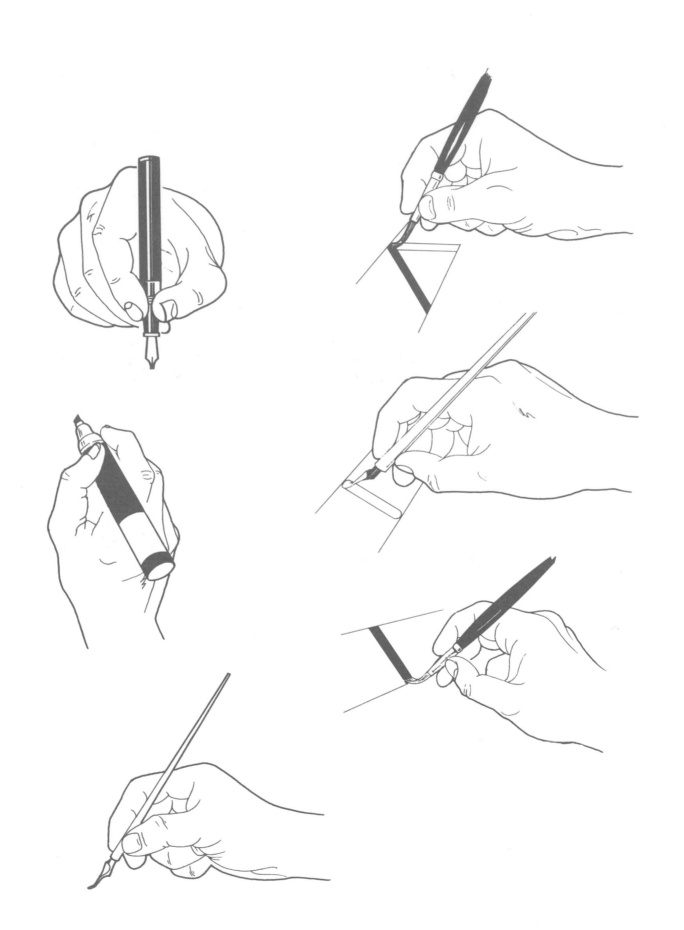

Abraham Switkin

Hand Lettering Today

HARPER & ROW, PUBLISHERS

NEW YORK, HAGERSTOWN, SAN FRANCISCO, LONDON

For Anne

HAND LETTERING TODAY. Copyright © 1976 by Abraham Switkin. All rights reserved. Printed in the United States of America. No part of this book may be used or reproduced in any manner whatsoever without written permission except in the case of brief quotations embodied in critical articles and reviews. For information address Harper & Row, Publishers, Inc., 10 East 53rd Street, New York, N.Y. 10022. Published simultaneously in Canada by Fitzhenry & Whiteside Limited, Toronto.

FIRST EDITION

Designed by Lydia Link

Library of Congress Cataloging in Publication Data

Switkin, Abraham.
 Hand lettering today.
 1. Lettering. I. Title.
NK3600.S98 1976 745.6′1 75-25067
ISBN 0-06-014204-9

76 77 78 79 80 10 9 8 7 6 5 4 3 2 1

Contents

part one

PRINCIPLES

OF

LETTERING

part two

TECHNIQUES

OF

LETTERING

Acknowledgments

Tribute is paid to the following for the high quality of professionalism shown in the examples included herein: Nat Teller, photographer; lettering artists Mike Breslin and Mauro DeRasmo, of Chartmakers, Inc., with additional thanks to William Dobek, also of Chartmakers, for his help and cooperation. To the following masterful calligraphers: William Fandl, Jeanyee Wong, Freeman Craw, Byron J. Macdonald, Lili Cassel, Donald Bolognese, Ann Camp (for her inspiring presentation), Thomas Barnard, and last but certainly not least, Lloyd J. Reynolds. Special thanks here go to Louis Strick, of Pentalic Corporation, for his encouragement. Further appreciation and acknowledgment are extended to the Dryad Press of England, to the Hunt Manufacturing Company, makers of the Speedball line, and to M. Grumbacher, Inc., a major maker and distributor of artists' supplies. I owe much to Victor Fina for his important contributions.

Special acknowledgment must be made to the Famous Artists School of Westport, Connecticut, for permission to use material from their excellent Course of Study in Lettering. This school offers instruction by correspondence in all aspects of the theory and practice of lettering. Their course is professionally sound, and so can be recommended to anyone wishing guidance and instruction, with professional criticism of work done. Further information may be obtained by writing to the school. My personal thanks to Mr. Fritz Henning, Director, for his cooperation.

A very special note of appreciation to Mr. Herman Romash, of Dri-Mark Products, a major manufacturer of marking pens, for his informative and authoritative answers to questions on the use of markers. Much thanks to Art Director Ann Sloane, of W. & J. Sloane, for permission to use several fine examples of informal script from their newspaper ad files, designed and rendered by artist-letterer Henry Margulies, and appreciation to Linda Bialous. My sincerest apologies to anyone who may have been inadvertently overlooked.

Finally, and most importantly, I want to gratefully acknowledge the major contribution of the Harper & Row team, who, very literally, made this book possible. First, Harold E. Grove, my editor, for being godfather, and for his patient, wise and expert guidance throughout. Then Lydia Link, for her great work in design and art values; Dolores Simon, for bringing the text up to professional standards with her observations and criticisms; Renée Cafiero, who increased my awareness of content with her astute copyediting; and Robert Cheney, for his excellent taste and good judgment. I am, indeed, extremely fortunate in having such a team of dedicated professionals at work in bringing this work to fruition.

Foreword

As present head of a busy lettering studio, the author is constantly faced with a logjam of work with short deadlines and the lack of skilled help. Our regular staff of experts is taxed beyond capacity, even with overtime at double rates. In spite of the not inconsiderable rate of $12 hourly, which is cheerfully paid, we have serious problems in finding outside help to pitch in at these frequent times of stress.

This is no unusual situation in busy studios, where for certain reasons instant type and photo lettering (both most useful shortcuts in many instances) cannot be used—for example, for color layouts, chisel point, and Speedball. All this points up the shortage of skilled letterers in all phases of advertising, from the sign, display, and silk-screen shops all the way up to top agencies and studios.

It is with this in mind that the author is attempting to pack a lifetime of experience in all phases of lettering, while concurrently teaching the subject on all levels from junior high school to adult professional, into a book that is intended to be a very practical guide. The step-by-step approach in each area dealt with should be very useful to teachers who may have limited practical experience in the field.

Professionals are usually specialists, and therefore necessarily lacking in the knowledge and experience of those areas outside their own specialty. For them, it is hoped that new areas will be opened, so they may broaden their usefulness. For these people, and in deference to their professionalism, the examples used are of the highest professional caliber.

This book, then, is strictly a how-to treatment of the subject, with little concern given the historical origins of lettering. These have been dealt with adequately elsewhere.

No one understands better than the author that no beginner can hope to become a full professional by the use of a textbook. Yet we believe it possible for a beginner, by a sincere application of the material herein, to reach a point of usefulness so that he or she may fit into a lettering studio in a limited capacity, and then, with day-to-day experience, develop into a full professional.

One last word. In spite of the mechanical aids available today in the production of lettering there is a constant and growing need for hand-lettering. There are more people at work in this field than at any time in the past. We see no reason for it to be otherwise in the future. On the contrary, the proliferation of advertising in recent times would indicate the opposite.

There always was, and will always continue to be, a worthwhile career open to anyone who qualifies, whether male or female, in the highly skilled and creative field of hand lettering.

Abraham Switkin

PRINCIPLES OF LETTERING

The Correct Basic Form of the Alphabet: The Capitals

There are thousands of alphabets in use today. They all differ in some way, yet all but about 1% are based on the same skeleton form. This basic form is closely adhered to by the designers of type, as well as the professionals who use type or freehand lettering in their daily work.

Regardless of character or style, regardless of varying proportions (such as condensed, normal, or extended), and in spite of differing weights and sizes (lightface, regular or bold), the basic skeleton form of each letter follows a fundamental design.

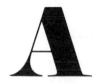

This is due to the fact that a well-designed letter is a carefully balanced unit in itself, within the space it occupies; this contributes to its legibility and appearance. Long experience has established guidelines that are accepted and used by all professionals.

The exceptions to this basic form are those few which are deliberately designed to vary from the basic form to achieve a novel effect. This has its use in unusual cases where some degree of legibility is sacrificed for novelty.

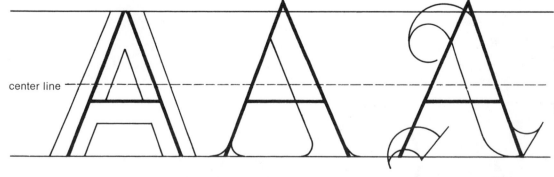

center line

Note that in spite of the wide variation of style, the skeleton is basically the same.

It is important, therefore, that students of lettering become familiar with this basic form, and adhere to it if they wish to do work which is considered professionally acceptable.

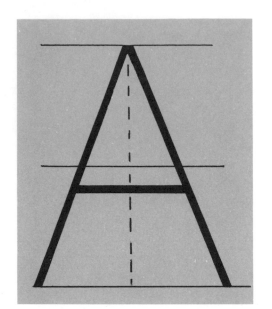

Diagonals are an equal distance from center of apex or base. Horizontal crossbar is always slightly below actual center, to visually equalize the space within the diagonals.

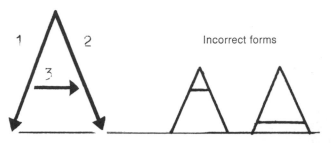

Incorrect forms

Middle horizontal stroke is slightly above actual center. Bottom half is slightly larger and wider than upper half. The three horizontal strokes are straight before turning into the curved parts of letter.

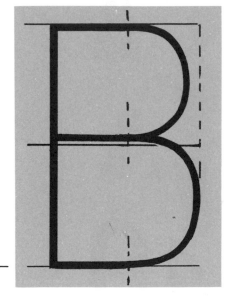

Incorrect forms

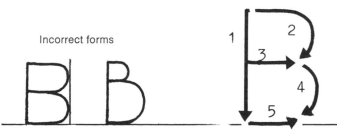

Curved letters always extend slightly above and below guidelines, to avoid appearing shorter than straight letters. End strokes are equal distance from centerline.

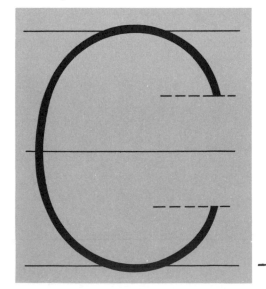

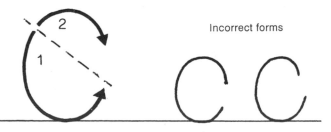

Incorrect forms

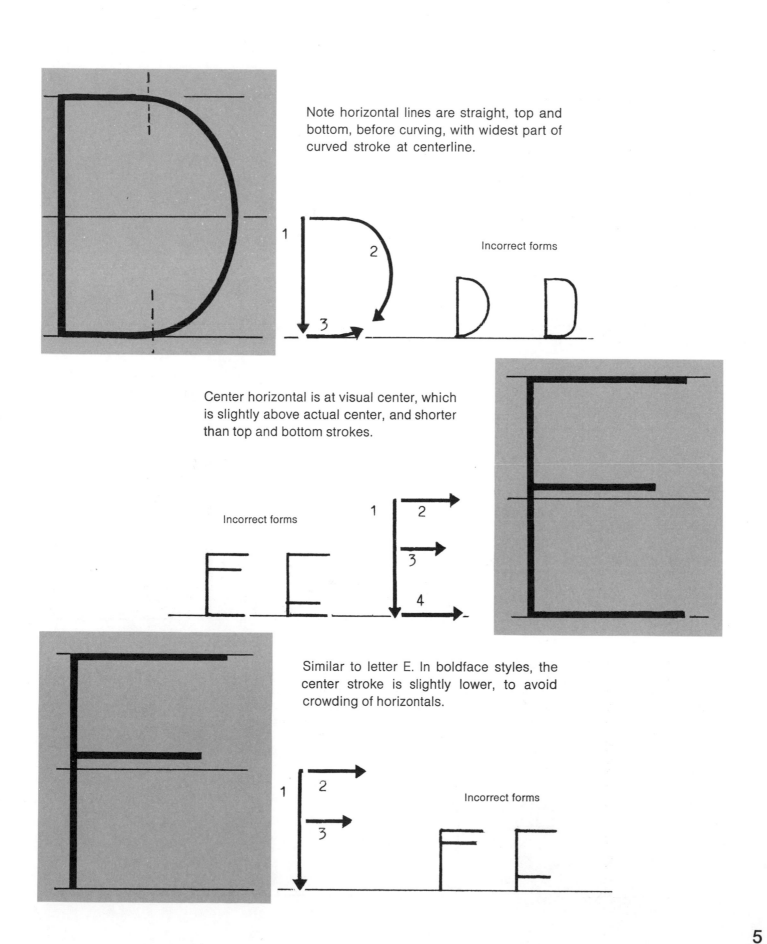

Note horizontal lines are straight, top and bottom, before curving, with widest part of curved stroke at centerline.

Incorrect forms

Center horizontal is at visual center, which is slightly above actual center, and shorter than top and bottom strokes.

Incorrect forms

Similar to letter E. In boldface styles, the center stroke is slightly lower, to avoid crowding of horizontals.

Incorrect forms

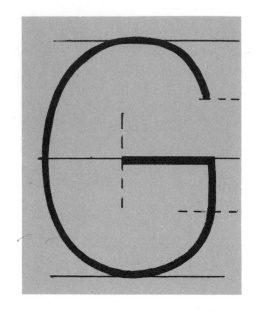

Similar to letter C, with vertical and horizontal strokes added, as shown.

Incorrect forms

Horizontal crossbar slightly above actual center, as in letter E, and for same reason.

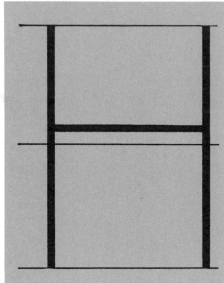

Incorrect forms

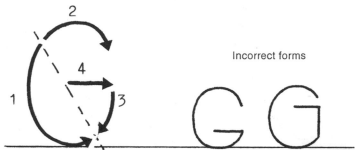

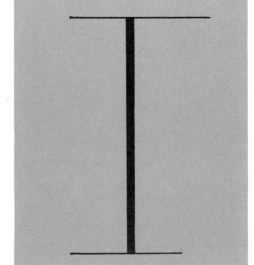

This letter consists of a single vertical stroke, extending from top guideline to base. Do not use crossbars or serifs unless other letters in style used contain them.

Incorrect forms

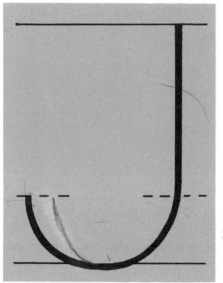

Vertical stroke curving to left at midpoint between centerline and base. Left end is reverse of letter C. Curved bottom stroke extends slightly below baseline.

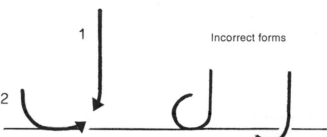

Incorrect forms

Vertical joined by two diagonal strokes. Note that upper diagonal extends below centerline, and lower diagonal forms wider base while extending to top of perpendicular.

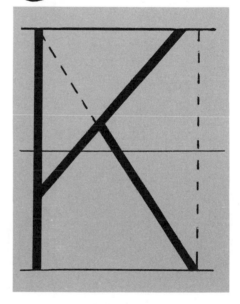

Incorrect forms

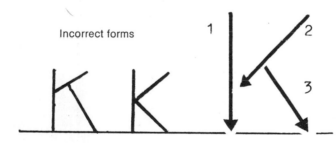

Similar to letter E, minus top and center strokes.

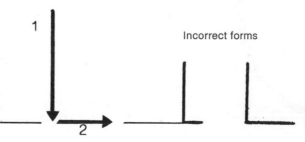

Incorrect forms

Two verticals, joined by two diagonals meeting at center of baseline.

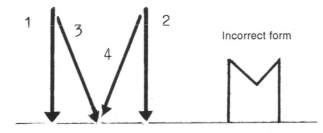

Incorrect form

Two verticals, joined by one diagonal extending from top left to bottom right.

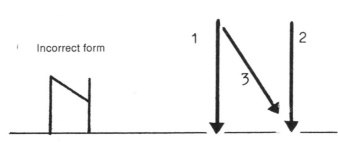

Incorrect form

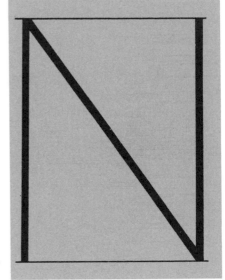

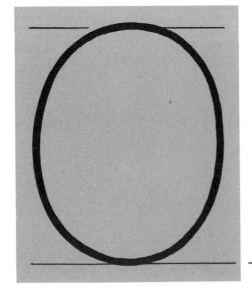

Similar to letter C, but completely enclosed, with slight extensions above and below guidelines.

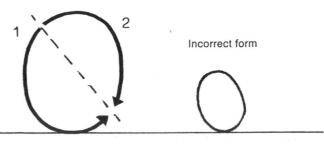

Incorrect form

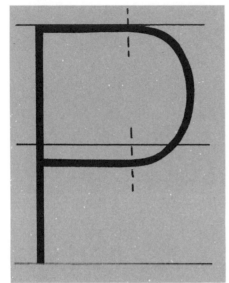

Vertical with curved stroke extending below centerline. Note short horizontals leading into curved stroke.

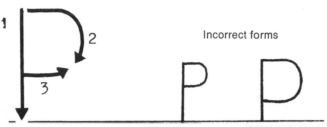

Incorrect forms

Similar to letter O, with tail added as shown. Both styles are correct, with straight tail better for heavy letters, and curved tail for Roman styles.

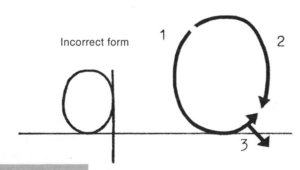

Incorrect form

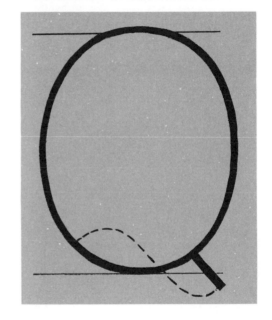

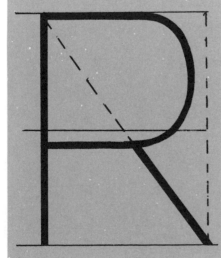

Upper part as letter P, with lower right stroke similar to letter K, making it slightly wider at baseline.

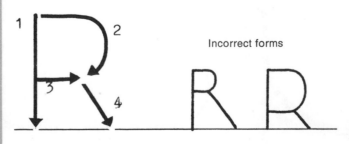

Incorrect forms

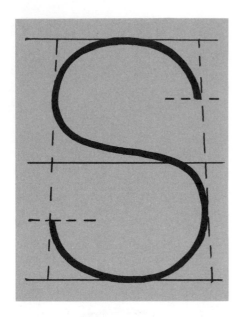

This letter, in any style, is based on two circles or ellipses, with the bottom one slightly higher and wider than the upper one. Ends are equal distance from center-line.

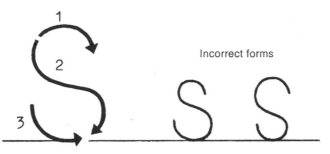

Incorrect forms

Horizontal top line joined at center by vertical stroke.

Incorrect form

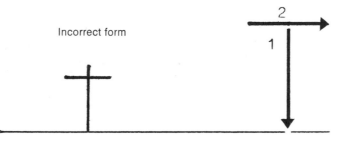

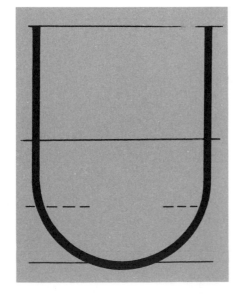

Two verticals joined by curved bottom stroke, starting at midpoint between cen-terline and base. Bottom curve is slightly below baseline.

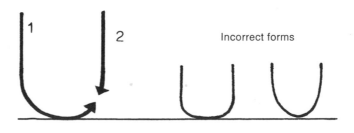

Incorrect forms

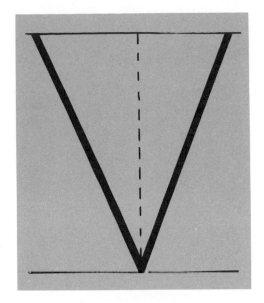

Two diagonals joined at center of base-line. Reverse of letter A, minus crossbar.

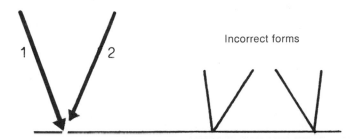

Incorrect forms

Formed by two V's, though each V is narrower than regular letter V to avoid oversize appearance.

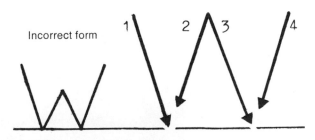

Incorrect form

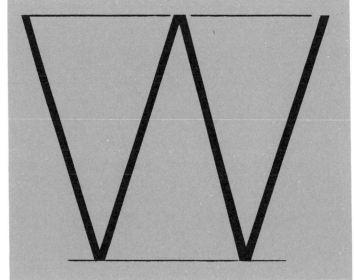

This letter crosses slightly above center-line, and is slightly wider at base—to avoid bottom half appearing to be smaller.

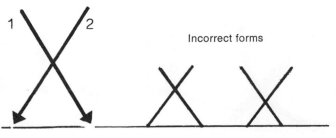

Incorrect forms

11

Formed by extending the upper V part to slightly below actual center.

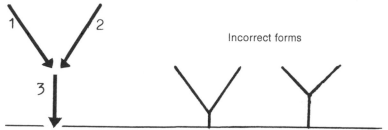

Incorrect forms

Slightly wider at base, as in letter X, and for the same reason.

Incorrect forms

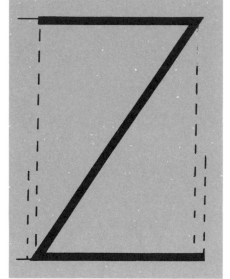

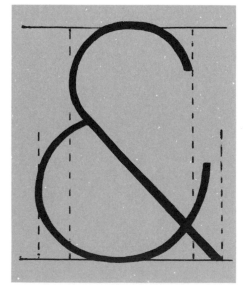

The ampersand, used in place of the word "and," has many popular variations. Shown here is a version which lends itself well to all styles.

& ? ! $ ¢ %

YOU CAN

INCREASE

DESIGN

RANGE

POWER

ORIGINALS

DESIGN

These hand-lettered examples indicate how closely the basic form is adhered to by professionals regardless of style, size or proportion of alphabet used.

Often, letterers find it necessary to change the proportions of letters to fit a space that is either condensed or extra wide. When this occurs, letters are made to fit the given area, while adhering to the basic correct form in all respects.

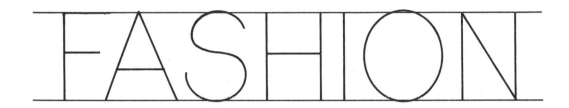

This is normal proportion, with letters slightly higher than wide.

Here we have extended letters. Note that the details are similar to the normal size.

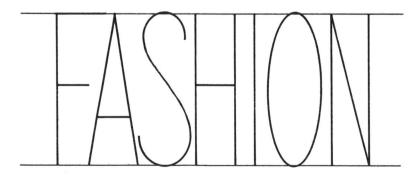

No matter how narrow, or condensed, letters are made, the basic form is unchanged.

The above establishes the universality of the basic form, which applies to practically all alphabets.

The Correct Basic Form of the Lowercase Alphabet and the Arabic Numerals

With few exceptions, all alphabets of capital letters have an accompanying alphabet of lowercase or "small" letters, as nonprofessionals term it.

These letters are easier to scan and read for several reasons. First, they closely resemble the handwriting we learned at an early age, and so are more familiar. Second, while the capitals require 74 strokes to form all letters, the lowercase require only 63 separate strokes. This means less black for the eye to grasp in reading, and so less of a strain on the reader.

Also, from the letterer's view, these letters are easier and faster to render, since the lowercase alphabet contains 18 letters with round strokes, with only 8 letters formed of all straight strokes, which are more difficult. The reverse is true of the capitals. There are 15 letters with all straight strokes and only 11 contain round strokes.

This makes for easier and faster rendering of lowercase letters, and so, where possible, these letters are preferable both for the renderer and the reader.

Surprisingly, the variation of detail is greater in lowercase, as is the relative size of these letters to the capitals. Yet it is possible to find a basic common form in most of the lowercase alphabets, as illustrated in the following pages.

It is important to note here that the same principles of good proportions used for capitals (a round letter is made wider than a straight letter, etc.,) and the rules of good letterspacing (two straight letters require more space than two round letters, etc.) apply equally to lowercase alphabets of all styles.

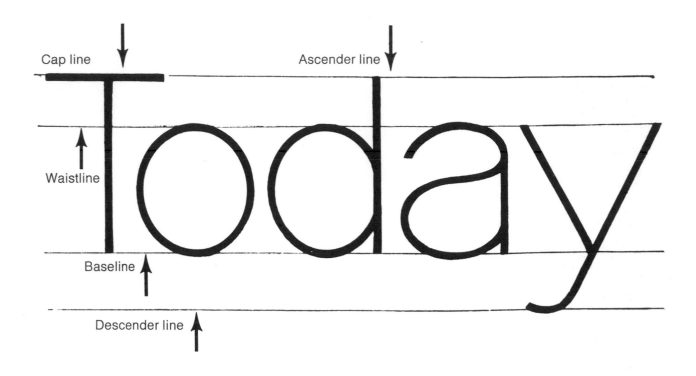

Cap line

Ascender line

Waistline

Baseline

Descender line

The comparative size of the lowercase letters to the capitals varies greatly among alphabets. However, most lowercase alphabets will be two thirds the height of the caps from waist to base. Ascenders go to full cap height, while descenders extend below baseline the same distance.

The letters with ascenders

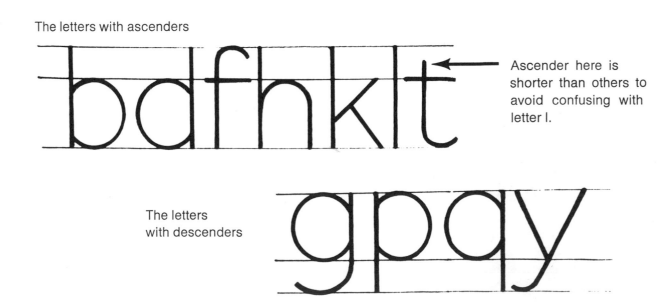

Ascender here is shorter than others to avoid confusing with letter l.

The letters with descenders

SEVEN MEETING ANNOUNCEMENTS
THAT SHOW SEVEN DISTINCT STYLES
OF PRINTING. WHILE THE NAME
"CAXTON" SUGGESTS THE VENERABLE
AND THE SCHOLARLY CONVENTIONAL
MANY OF THESE PIECES SHOW A
HAPPY ADAPTATION OF AN HISTORICAL
EMBLEM TO A DISTINCTLY MODERN
STYLE OF PRINTING. THERE IS AN AIR OF
FREEDOM ABOUT THESE DESIGNS; IT IS
MODERN PRINTING WITH A DIGNIFIED
TOUCH. THE TREATMENT OF THE CLUB
SYMBOL IS ESPECIALLY INTERESTING
BY THE LAKESIDE PRESS CHICAGO

These two bodies of copy are set in the same size type, and occupy the same space. One is lowercase, with an occasional cap, and the other all caps.

It should be obvious that the lowercase is much easier to read. It requires 12 lines rather than the 14 lines of caps for the same message.

Add to this the fact that the lowercase is formed of fewer actual strokes of the brush, and we see why it is preferred to the caps, wherever it is possible, from the viewpoint of the letterer as well as the reader.

Seven meeting announcements that show seven distinct styles of printing. While the name "Caxton" suggests the venerable and the scholarly conventional, many of the pieces show a happy adaptation of an historical emblem to a distinctly modern style of printing. There is an air of freedom about these designs. It is modern printing with a dignified touch. The club symbol treatment is very interesting. By the Lakeside Press, Chicago.

The rounded lower half of this letter extends to the left of the upper part, in all alphabets

The center horizontal is at visual center, slightly above actual center

The bottom curve does not extend to full width of the upper part

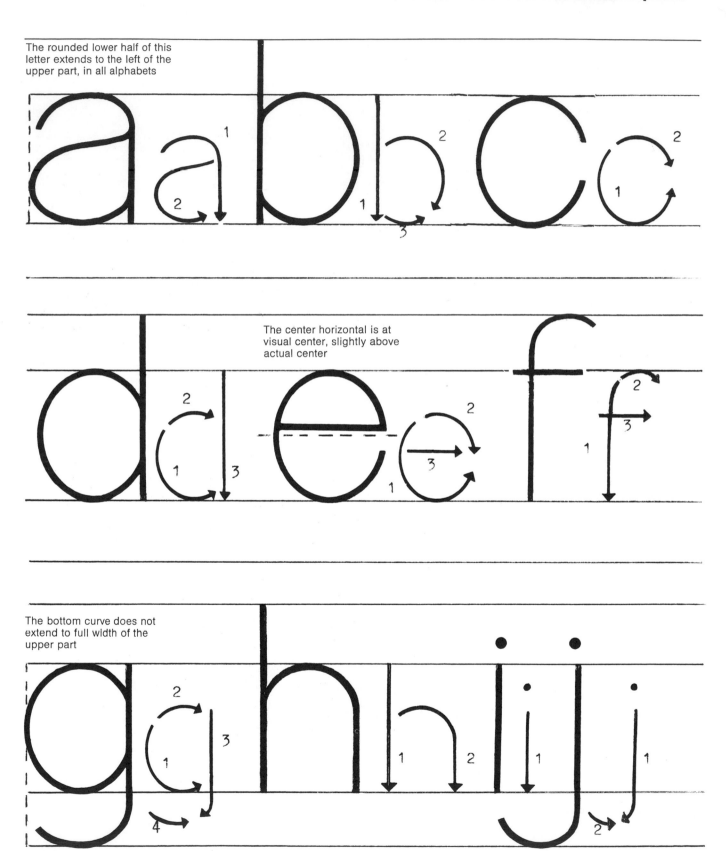

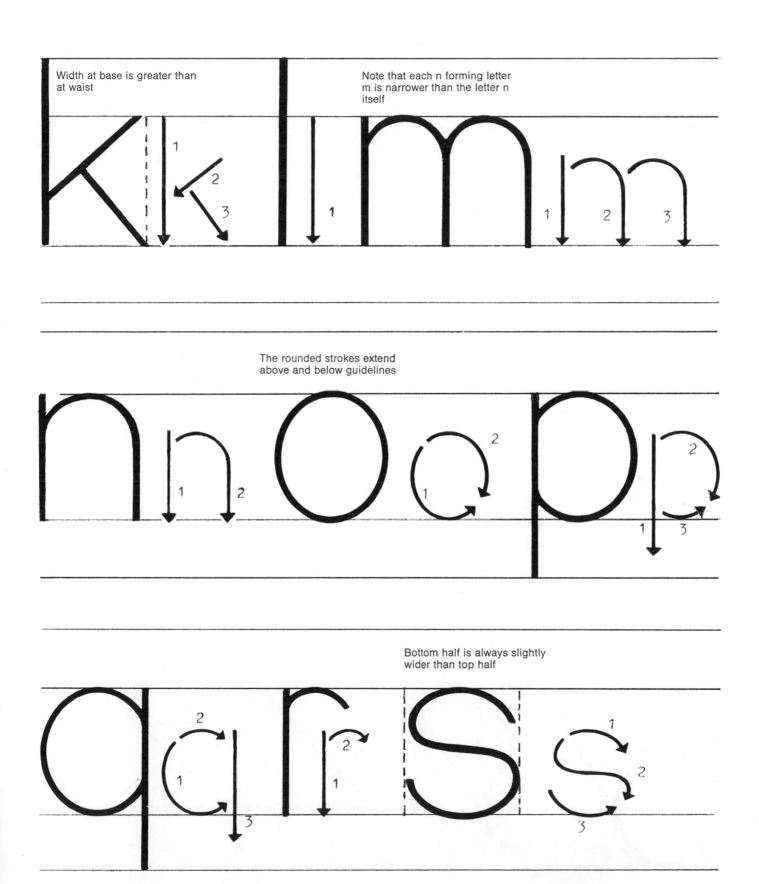

Width at base is greater than at waist

Note that each n forming letter m is narrower than the letter n itself

The rounded strokes extend above and below guidelines

Bottom half is always slightly wider than top half

19

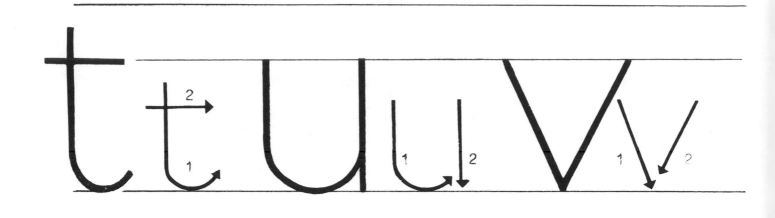

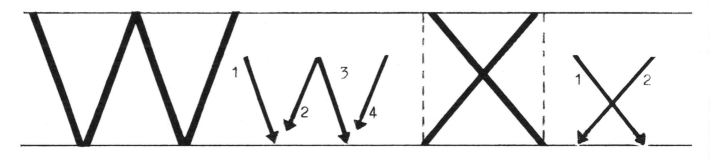

Note that each v of letter w is not as wide as the letter v itself

Slightly wider at base

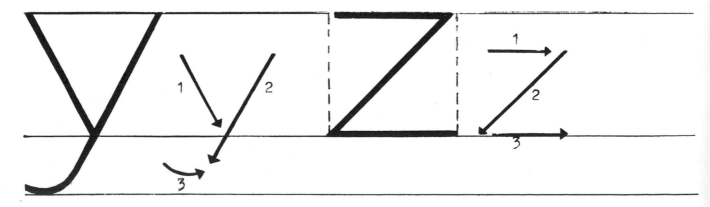

Slightly wider at base

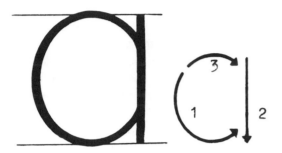

Bug us for an autograph.

is fantastic

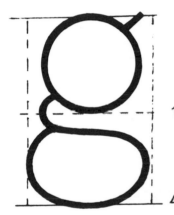

The descender is one-fourth wider than the top, and is half the vertical space of the letter

go exciting

Let's forget work

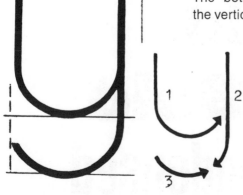

The bottom curve extends slightly past the vertical stroke above it

ability

In the field of type and printing, the weights (thicknesses of stroke) are rigidly fixed and will vary only when a letter is reduced or enlarged.

In hand-lettering, any style may be made in any weight, according to the needs of the job, thus allowing greater flexibility and variety.

The style shown here, Helvetica, is derived from the most popular Gothic style in use today. It illustrates some of the weights possible. In addition, any given style may be further varied by condensing or extending the form itself, thus further amplifying the use of alphabets.

Helvetica Hairline

Helvetica Light

Helvetica Regular

Helvetica Medium

Helvetica Demi-Bold

Helvetica Bold

Helvetica X-Bold

Extended Condensed

Basic Form of the Arabic Numerals

The base extends beyond upper curve

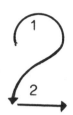

Based on two circles the bottom one is slightly larger

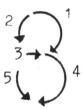

The horizontal is placed one fourth of full height above base line

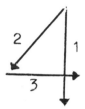

Bottom half is wider and higher than upper part

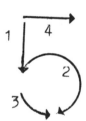

Bottom half extends beyond upper end

Base is at left of horizontal midpoint

Similar to numeral 3, completely enclosed

Reverse of numeral 6

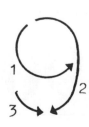

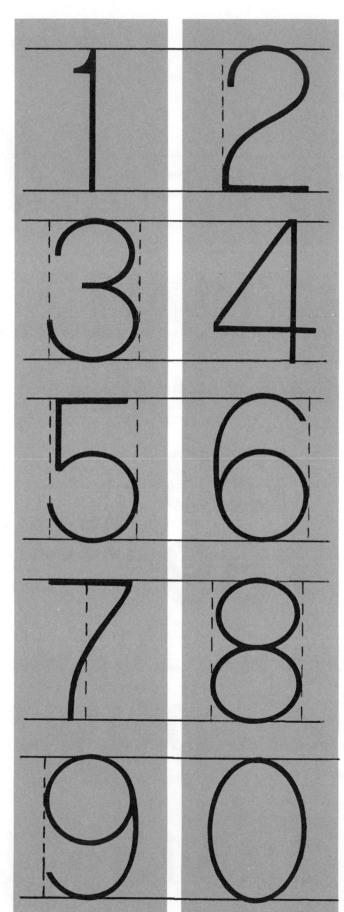

The Principles of Correct Letter Proportions

Letters are not intended to be read individually but are unit parts of words, which, in turn, form sentences and convey a thought. As such, the separate letters must be unobtrusive to permit the instant scanning of the word and sentence. Anything which interferes with the rapid comprehension of the word must slow down the reader, perhaps even confusing him to the point where he will lose the gist of the message and stop reading further because of the imperceptible strain on his eye and mind.

In speaking of letter proportions we refer to the comparative relation in size (height and width) of one letter to another.

In the illustration below we see an example of what happens to legibility when letters are put together with a total disregard for letter proportions. Lacking uniformity, the title words must be laboriously deciphered to be read and comprehended. Fortunately, there are only three words involved. The eleven words at the top, while much smaller, can be read in less time and with less strain than the three distorted words, proving the importance of letter proportions.

If uniformity is so essential to legibility, why are letters not simply made all exactly the same size? Would not this ensure uniformity?

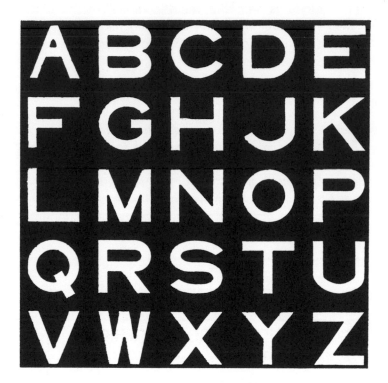

In the above illustration, every letter has been drawn to occupy the exact same space. A careful look discloses that the letter B appears to be noticeably wider than the letter A. Again, the letter E appears wider than the letter C. The W certainly looks narrower than the R or P. There are many other discrepancies which can be noted.

Letters thus made, all exactly alike in size, would give an irregular and uneven appearance, making for poor readability.

We may fairly state that:

If all letters are made alike in height and width, they will appear to be unlike in size, and out of proportion to each other.

Now let us understand why this must be so. It is a simple visual fact that if we draw a square and a circle the exact same size and place them alongside each other, the square will always appear to be both higher and wider than the circle. See below.

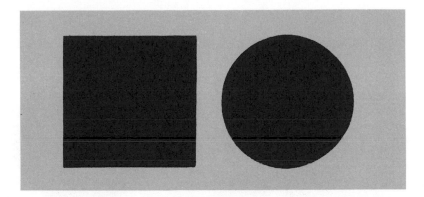

This is an optical illusion due to the fact that the square fills the occupied space more fully than the circle, making it *appear* to be larger. This optical illusion must be considered if we are concerned with making the two figures appear to be similar in size and appearance.

Letters are formed of straight and/or curved lines. They fill any given area differently due to their various shapes. In place of the square and circle, let us use letters most closely related to them, the E and O, and to illustrate the point better, we will use a rectangular and an oval figure.

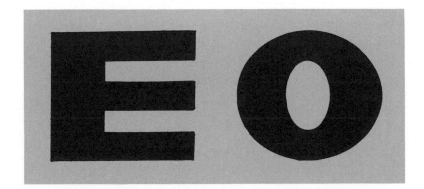

The above two letters are exactly the same height and width. Note that the letter E appears to be both higher and wider than the letter O. This kind of irregularity must be avoided to ensure good legibility.

We now make the adjustment necessary to make the two letters appear to be uniform in size.

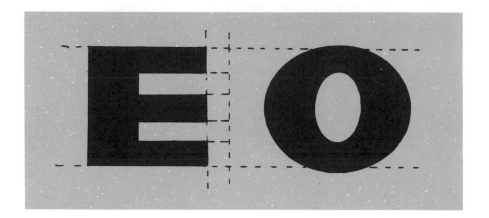

We do this by making the letter E somewhat narrower by approximately 20% and the letter O somewhat higher by extending it above and below the guidelines. Slightly, to be sure, but sufficiently to make the two letters visually the same size. The extent to which this is done can be noted in our detailed alphabet of letter proportions further on.

Similarly, all other letters which are composed of straight and curved lines would require the same adjustment.

We may now state, as a basic principle of good letter proportion, that *to make letters appear to be alike in size, we must actually vary them in size.* When this fact of lettering life is clearly accepted and the reasons for it understood, we will have taken a long step toward professionalism.

Fortunately for letterers, there are not twenty-six different letter proportions. The various letters of the alphabet, because of their differing shapes, fall into several categories. Actually, for convenience and expediency, professionals consider only four different shapes requiring an adjustment in height or width, plus two exceptions.

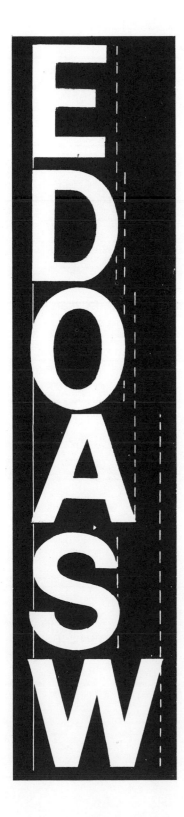

First Group

Letters with all straight strokes are narrowest (J and U are exceptions which best fit here).

EFH (J) KLNT (U) XZ

Second Group

Letters with straight and round strokes are wider.

B D P R

Third Group

Letters with all round strokes are wider than above.

C G O Q

Fourth Group

Wedge-shaped letters are widest.

A M V Y

Exceptions

Formed of double circle, this fits best in second group.

S

Being a double letter V, this is the widest letter in every alphabet.

W

Since the relative widths of letters will always vary according to their shapes, the previously stated rules for capital letters will apply to the lowercase alphabets.

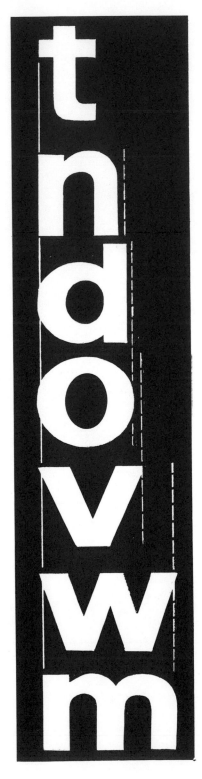

First Group

The narrowest are those letters formed of a single upright stroke with short identifying horizontals.

f i j r t

Second Group

Letters with two vertical strokes are the narrowest of the regular letters.

h n u k x z

Third Group

Combinations of straight and round strokes are slightly wider than above.

a b d g p q

Fourth Group

Letters with all round strokes extend beyond above group.

c e o s

Fifth Group

Wedge-shaped letters are wider than above group.

v y

Exceptions

These two letters are the widest in all lowercase alphabets. Both are double letters, but are less than full double width of their single basic forms, the n and v.

m w

Good Letterspacing: The Why and How

As in dealing with the proportions of letters, we are concerned with putting letters together to form words in such a manner that the word is seen as a unit and instantly grasped. This involves the avoidance of any irregularity in appearance.

Below, we see an example of a word wherein the letters are correctly formed, the proportions are balanced and the rendering is professional, yet the word is difficult to read at a glance.

WASHINGTON

This is due to the fact that the letters are *uniformly* separated, making no allowance for the differing shapes of letters, thus achieving an unevenness which makes legibility poor.

Now let us see what happens when the same word is spaced *visually*, that is, varying the space between letters in accordance with the differing shapes of the letters.

WASHINGTON

We may now state that:

● *LETTERS WHICH ARE UNIFORMLY SPACED WILL APPEAR LACKING IN UNIFORMITY.*

And therefore:

● *TO MAKE LETTERS APPEAR TO BE UNIFORMLY SPACED WE MUST VARY THEIR SPACING.*

How, then, do we achieve this visual uniformity?

Professionals have learned from long experience that certain combinations of letters, due to their shapes, will require more space between them than others to appear to be uniformly apart, while others require less space to achieve uniformity. These well-established rules are based on visual facts which must be considered in putting letters together.

For example:

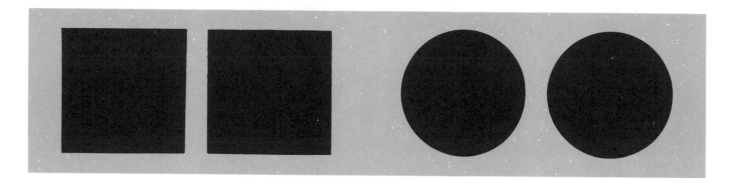

Note what happens when two squares are placed the same distance apart as two circles of the same height and width. The circles will always appear to be farther apart.

Now let us allow more space between the two squares than the circles. They will now appear to be the same distance apart.

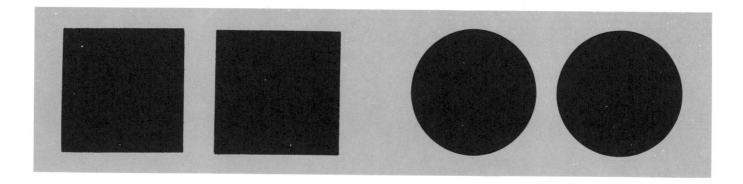

The two squares require more space between them to appear the same distance apart as the circles. This is obviously due to the fact that the two circles are not enclosed by parallel lines and therefore occupy the same space differently. The visual space between the figures includes all of the white area between the shapes.

Substitute the shapes of letters for the preceding geometric figures and you have the visual basis for letterspacing—and the need for it if we are to achieve *uniformity in appearance,* so essential to good legibility in a line of copy.

We may now state the rules of good visual spacing:

Letters with adjoining vertical strokes are farthest apart.

HE

Letters with a vertical next to a rounded letter are slightly closer.

OD

Letters with two rounded strokes adjoining are even closer than above.

OO

Wedge-shaped letters may overlap without touching.

TA

There are other combinations of adjoining letters, too numerous to mention here, which require visual judgment. These are to be related to the spacing for the above basic categories.

There are other combinations of adjoining letters which do not fall easily into any of the above categories. Some of the major exceptions are dealt with below. Others will require visual judgment and are to be related to the spacing used in the major categories described.

Some of the unusual combinations are:

Two wedge-shaped letters that adjoin will have their diagonals spaced similarly to two verticals, as in HE.

This combination will overlap, to minimize the large area between the verticals.

Very close indeed because of diagonal in A.

Even closer than above.

Overlap due to broken area.

TECHNIQUES OF
LETTERING

The Technique of Free-Hand Brush Lettering for Nonreproduction Purposes

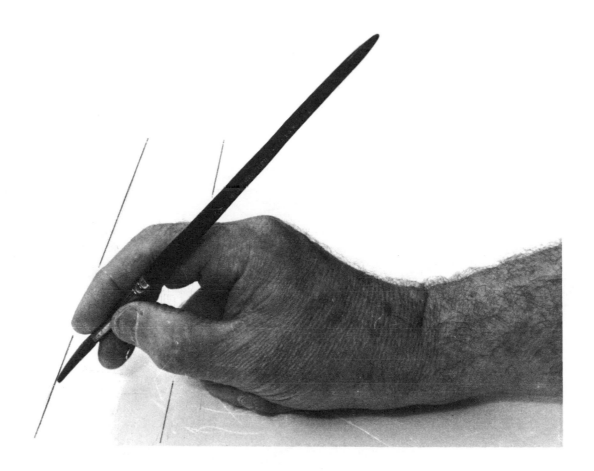

The essential difference between lettering with a brush and ordinary writing with pen or pencil is that whereas writing is done by a movement of the fingers while the arm and hand remain stationary, lettering with a brush is done by moving the hand and arm while the fingers are stationary.

In both cases the tool is firmly held in practically the identical position, between the first three fingers, as illustrated, with the last two fingers curled into the palm. The hand and arm move smoothly in the direction of the stroke being made while resting on the edge of the palm and the second joint of the small finger.

The skill of the lettering expert lies in his ability to control and guide the brush to make the six different strokes necessary to form all letters, as explained herein.

While this is not inflexible, certain preparations will make it easier to do this work, especially for practice.

Below is a suggested arrangement of the minimum tools and materials required and essential for practice work.

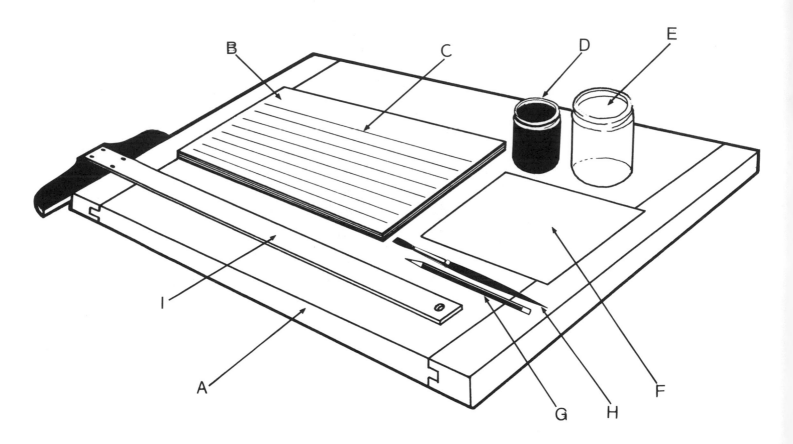

a. Drawing board or table at slight tilt
b. Newsprint pad 18″ × 24″
c. 1½″ apart, penciled line spaces for lettering
d. 2-oz. jar of poster paint (black)
e. Larger jar for clean water, to dilute paint as needed and keep fingers and brush clean
f. Cardboard palette
g. HB pencil
h. Red sable square-tipped rigger, size no. 12
i. T square ruler

Not shown: cotton rag for wiping fingers or brush
60–30 triangle

Each of these strokes requires a somewhat different position of the brush in the hand. Together, they will form all the letters in the alphabet. See detailed explanation that follows.

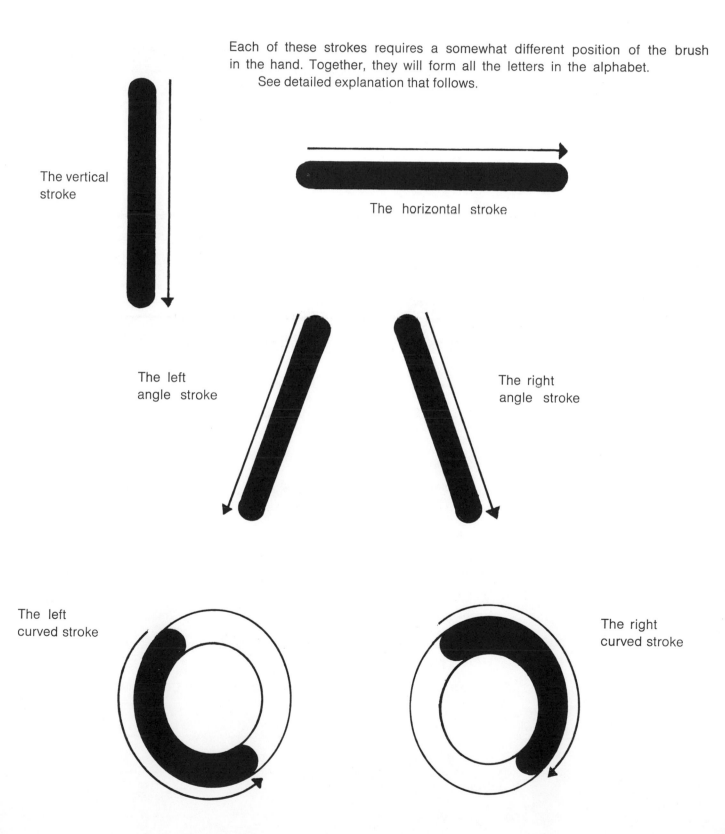

The vertical stroke

The horizontal stroke

The left angle stroke

The right angle stroke

The left curved stroke

The right curved stroke

The accepted and most widely used tool of professional brush letterers is the red sable rigger. This brush is made of selected hair of the furred red sable, with polished copper ferrule (the metal part which contains the hair). It is shaped to a chisel edge for square-edge letters. The long handle is made of hardwood and shaped for comfortable handling.

These brushes may be obtained in several lengths of hair, each length coming in a variety of sizes (width of edge), for various weights and sizes of strokes.

Care of the brush:

Being expensive, and the most important tool in the letterer's equipment, the brush rates proper care. Observe the following:

- Keep it clean. Wipe smudges of paint from handle or ferrule;

- Do not allow brush to stand upright in a water jar, resting on the hair. This will curl or bend the hair. Place it flat when not in use, even momentarily;

- Never, never allow paint to harden in hair;

- Rinse thoroughly in clean water, removing all traces of paint after using, and put away in flat position.

These few and simple rules will keep your brushes in good working condition for years.

A
B
C
E

Professionals use two methods in brush lettering for work that is not to be reproduced. One is known as the flooded-brush method and the other is the flat-stroke or chisel-edge brush technique. Both are done with the same brush used somewhat differently. The resulting effects are shown below. Note that one stroke has a rounded edge while the other is sharp and flat. Both techniques are fully explained and illustrated in following pages.

A
B
C
E

11

M. GRUMBACHER

12

M. GRUMBACHER

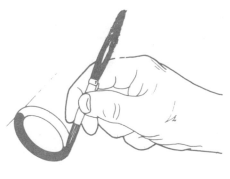

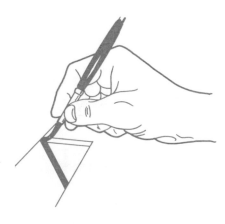

The flooded brush

The flat stroke

The Flooded-Brush Method of Lettering

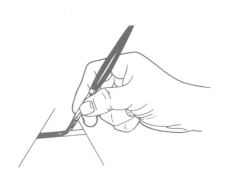

This technique, sometimes called the single stroke (since it requires no finishing strokes to sharpen the edges), is a most useful way of doing lettering in those cases where great accuracy is not required, but where time and speed are important.

It is used for signs, showcards, displays, silk-screen originals, and in recent years, in the growing field of advertising presentations of all kinds.

Letters may range in size from ½″, and even smaller, to practically any height. Styles are necessarily limited to the plain Gothic or block, although upper and lowercase, italic, and informal scripts lend themselves well to this technique.

Because of its importance, a detailed explanation follows, with practice procedures for those who may wish to develop this technique.

Below is a full-size portion of an actual job.

SHION

These used professional examples are 9″ × 44″, and are lettered at an average rate of 10 per hour. Letter size is 2½″ made with a no. 12 rigger.

LUSTRAY LABS INC.

HEALOX CO. INC.

After filling the brush properly, apply brush to the top of the 1½″ space, touching the line but not extending above it. With a steady hand and a full arm movement, make a vertical stroke that is uniform in thickness. Avoid any heavy pressure on the brush and draw the brush downward as easily and as rapidly as though doing this with a pencil.

End the stroke *at* the line—neither above nor below it. Stop at the baseline for an instant and lift the brush off the surface—not dragging the brush but *lifting* it.

Practice is successful only when the stroke is well rounded at both ends, and uniform in thickness from top to bottom.

Refill the brush every third or fourth stroke. Practice work should look like this:

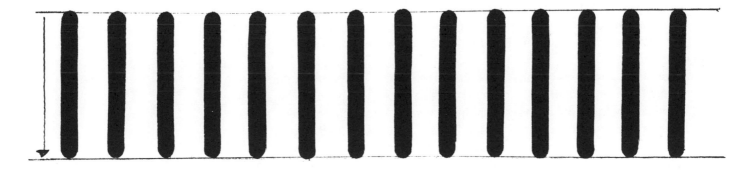

Consider this stroke a letter I, and continue across the page. This first practice will require some time and student may have to make a number of pages of such strokes before learning to control the brush.

The skill developed here will carry over into the next exercise.

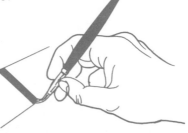

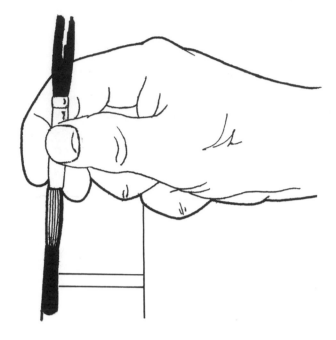

This stroke is best and most easily made when the brush is held in a somewhat different position from that of the vertical. It is held in a more upright position and tilts definitely to the right, enabling the arm to move the brush easily from left to right. The hand rests fully on the edge of the palm, with the last two fingers tucked into the palm.

Now, place the loaded brush at the top line, not above it, and move the entire hand and arm from left to right in a single smooth stroke. Pressure on the brush must be uniform. Begin with a fully rounded stroke and end with a similar one.

When beginning this stroke, rest the brush for a moment on the surface being lettered, to allow the paint to spread evenly, and pause again at end of stroke before lifting the brush from the surface. Quick, jerky starts and finishes must result in rough ends. Should this occur (and it does with all pros), a brief touch of the brush will serve to smooth it.

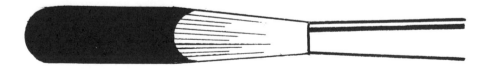

Note the horizontal strokes below. These can be done, for practice work, as shown using a no. 12 red sable rigger.

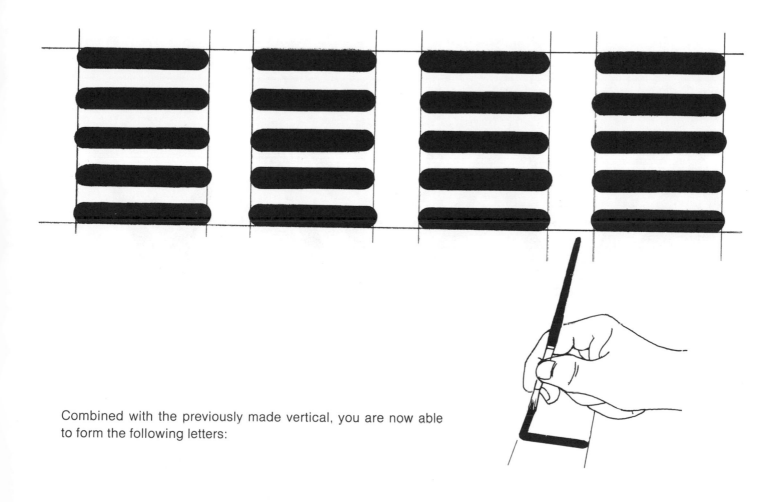

Combined with the previously made vertical, you are now able to form the following letters:

For further practice, you may attempt to letter these words:

THE · LIFT · HILT · LEFT · FELT · THEFT

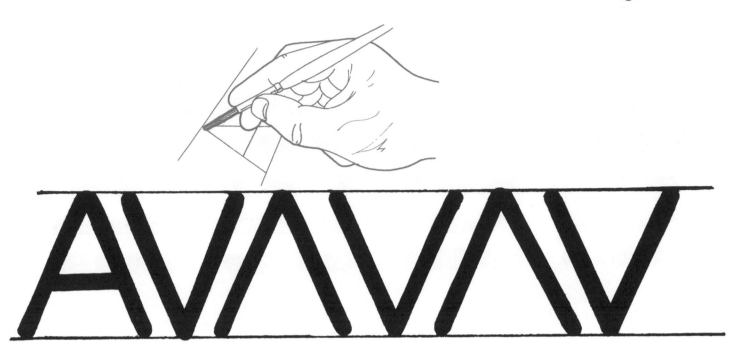

The left and right angle strokes are part or all of ten letters. In rendering, the brush is used exactly as heretofore, except that the entire hand is turned to the right or left, and the entire brush is tilted in the direction of the stroke being made, as shown.

Again, these strokes must start and finish *at the line,* not above or below it, and are formed with the same full arm movement as explained before.

These strokes, together with the verticals and horizontals, enable you to form the letters shown below. For practice work, use such words as:

WALL · FAN · KILT · NAIL · THANK · MINE

AKMNV
WXYZ

The two strokes forming the letter O are made by all pros in a special way, for greater ease and proficiency. Instead of forming half circles on each side of a center perpendicular, the strokes are made as shown.

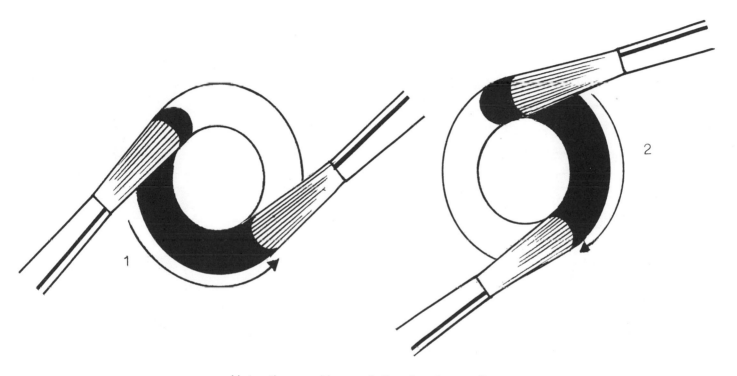

Note the positions of the brush as it swings around each arc. Each stroke is made in a continuous movement of the arm wherein the hand is turning as the stroke progresses.

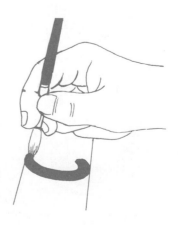

Note that the first stroke starts below the top and to left of center, then ends at right of center. The second begins at the top of the first stroke and then swings around to join the first part. Made this way, the two curves permit a free and easy movement of the arm without the strain which would result from the formation of two equal arcs on both sides of a centerline.

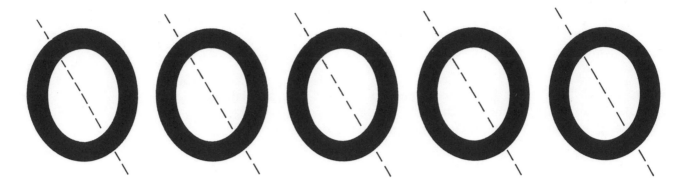

When this is achieved, you will be able to form all those letters which are combinations of straight and curved strokes:

B C D G J O P Q R U

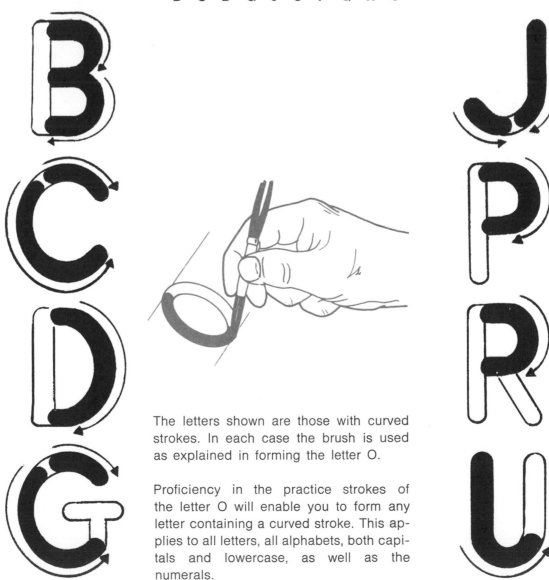

The letters shown are those with curved strokes. In each case the brush is used as explained in forming the letter O.

Proficiency in the practice strokes of the letter O will enable you to form any letter containing a curved stroke. This applies to all letters, all alphabets, both capitals and lowercase, as well as the numerals.

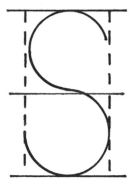

This letter consists of a compound curve, different from any other in the alphabet. Experienced professionals, without exception, have developed a method of forming this letter with a brush in a manner that is relatively simple.

In our study of correct form we learned that a correctly formed and well-balanced letter S is based on two circles, or ellipses, with the bottom half slightly higher and wider than the top. Keeping this in mind, we proceed to form the letter with three separate strokes, from the top down, as follows:

1: The first stroke starts at the left of center and ends a quarter of the height from the top.

2: The second stroke will begin at the left side and swing around to a quarter of the height from the bottom, ending just before the imaginary center perpendicular. Since the bottom is larger and wider, we extend the right side a bit past the upper stroke.

3: The third stroke starts a bit to the left of middle stroke and swings into the end of this stroke.

This construction applies to all styles and alphabets.

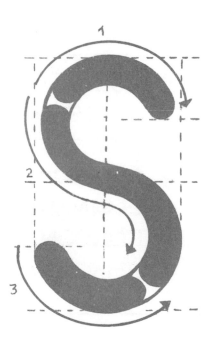

Practice strokes for the letter S

SSSSS

Examples of the flooded-brush technique. The letters are 2″ high, rendered freely and quickly with a rigger, size no. 12

PLEASE REGISTER BEFORE
PURCHASING AN ADMISSION TICKET

- ZODIAC-VACHERON-CONSTANTIN
- SUBERI BROTHERS, INC.
- MOREL JEWELRY DISPLAYS
- ROCKSON JEWELRY MFG. CO.
- ELGIN WATCH CO., INC.
- RONSON
- SEIKO TIME CORP.

MAJESTIC DRUG CO. INC.

ZODIAC LABORATORIES INC.

A Gothic style with the look of a Roman letter. It lends itself to the flooded-brush technique since all end strokes and serifs are uniformly rounded. In using this style, letters must be more carefully spaced in the layout to provide space for the serifs. Variation of weight can be made with use of larger size brushes.

YOUR
FUTURE
IS IN
YOUR
HANDS

We just made your

HERE
IS AN
IDEA !

"HELP YOURSELF"
SALAD MEAL

· · · · · · · · · · · ·

Everybody enjoys his
own choice of slimming
foods with tempting
variety in flavor —

Which is the most valuable?

This style can easily be made with a flooded stroke and provides an interesting variation of the bold Gothic.

A more finished appearance is obtained by a brief retouch of the inside of rounded strokes, as b, d, h, p, and s.

Weekend Sales at

A touch of the dial!

HEADINGS

This style may be used in different sizes, weights and proportions.

Like the flooded-brush stroke, this technique is most useful to the free-hand brush letterer. The full width of the brush is used to form the major parts of a letter with a single stroke. The strokes are then briefly sharpened as described to impart a visual finished appearance.

This means using a brush wide enough to make the full weight of the letter, thus saving time and achieving a uniformity which is more difficult with a double stroke or built-up letter.

Again, as with the flooded brush, it looks well on signs, showcards, displays, presentations, layouts, and silk-screen originals, where close adherence to a type style is not required.

The
vertical
stroke

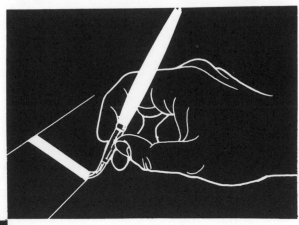

The
horizontal
stroke

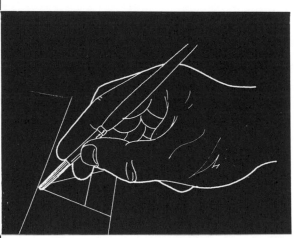

The
angle
stroke

The
curved
stroke

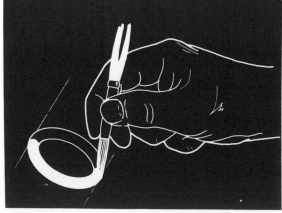

54

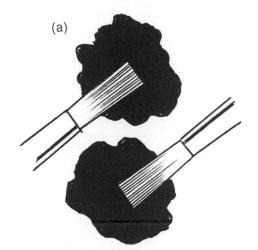

(a)

(a) The preparation for this method of lettering is similar to the flooded-brush method. When the brush is charged with paint, as before, instead of leaving it rounded, you will now press brush down on palette to flatten it. Do this first on one side of the brush, then, turning it on the opposite side, do the same. This serves to remove excess paint and readies the brush for work.

(b) Now, holding the brush in same position as before, and using the same full-arm movement, make the vertical stroke. This is started slightly below the top line, and stopped just before the bottom guideline. Pause momentarily before lifting the brush off the surface, to avoid dragging it below the line. The top and bottom of this stroke will necessarily be irregular, which brings us to the finishing strokes.

(c) You will now add two short strokes to make the full vertical sharp and flat. Making certain the brush contains no excess paint, and resembles a chisel, turn the brush so that the edge is parallel to the vertical, and make a short horizontal stroke across the top, as shown. Similarly, the bottom is completed.

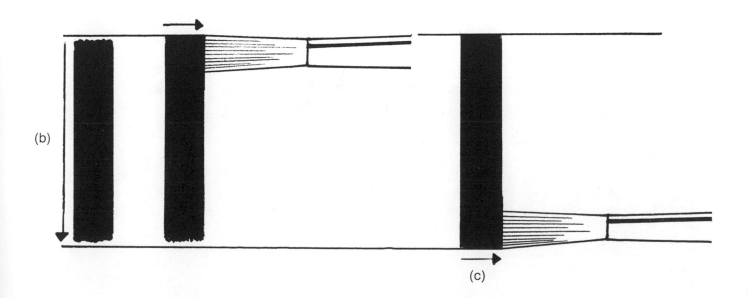

(b)

(c)

For the horizontal strokes of letters such as E or T, the main part of the stroke is made with the flattened brush. Note the position of the brush in forming this stroke. Again, the edge of the brush is held parallel to the stroke being made and the corners are made sharp and flat, as with the verticals.

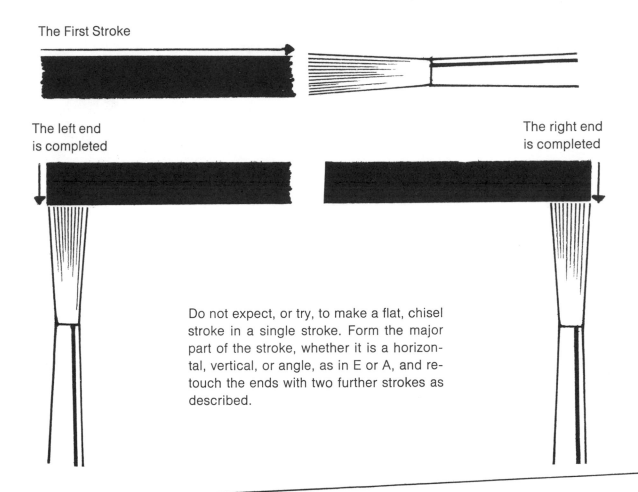

The First Stroke

The left end
is completed

The right end
is completed

Do not expect, or try, to make a flat, chisel stroke in a single stroke. Form the major part of the stroke, whether it is a horizontal, vertical, or angle, as in E or A, and retouch the ends with two further strokes as described.

EXHIBITOR REGISTRATION

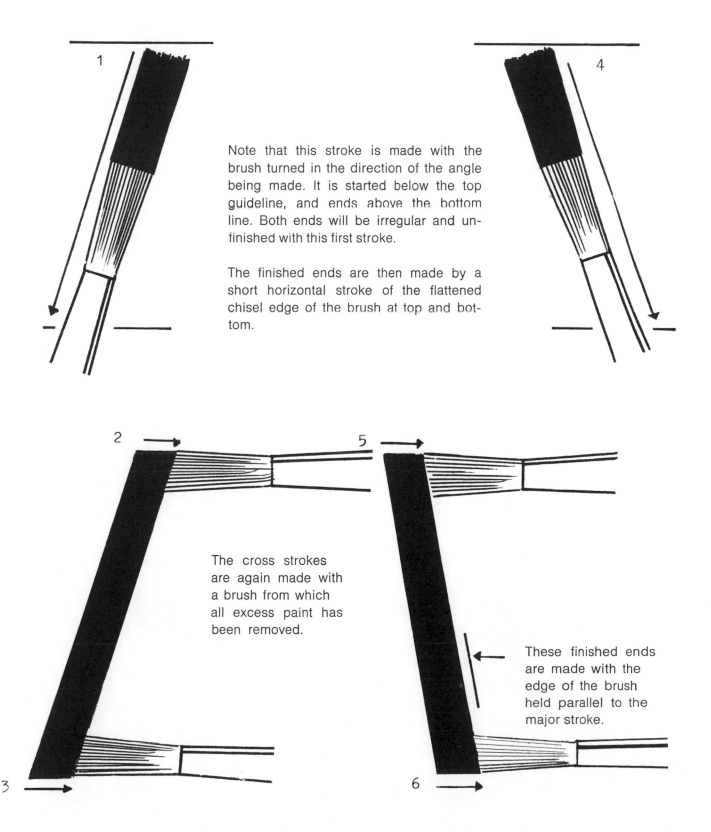

Note that this stroke is made with the brush turned in the direction of the angle being made. It is started below the top guideline, and ends above the bottom line. Both ends will be irregular and unfinished with this first stroke.

The finished ends are then made by a short horizontal stroke of the flattened chisel edge of the brush at top and bottom.

The cross strokes are again made with a brush from which all excess paint has been removed.

These finished ends are made with the edge of the brush held parallel to the major stroke.

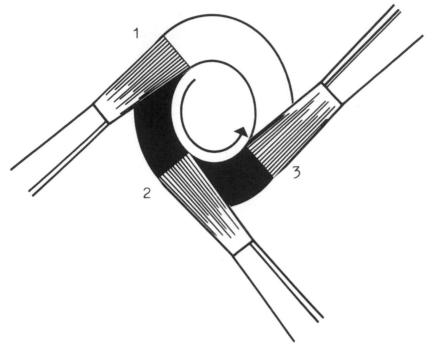

Note the position of the brush as it swings around the left arc.

This is done best by turning the brush in the hand as it makes the curved stroke.

This is essential to keep the stroke uniform in thickness all the way around.

Similarly, the right side of the letter is made with the brush in position 1, and turning it between the fingers as it completes the swing from 2 to 3.

Each side of this letter is made separately, with a continuous movement of the arm. The strokes will overlap at the start and finish of the right side.

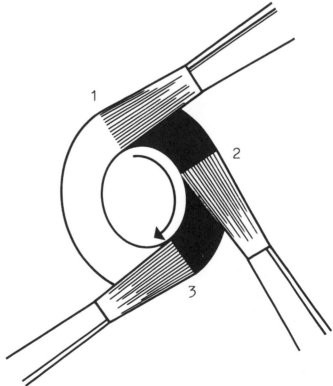

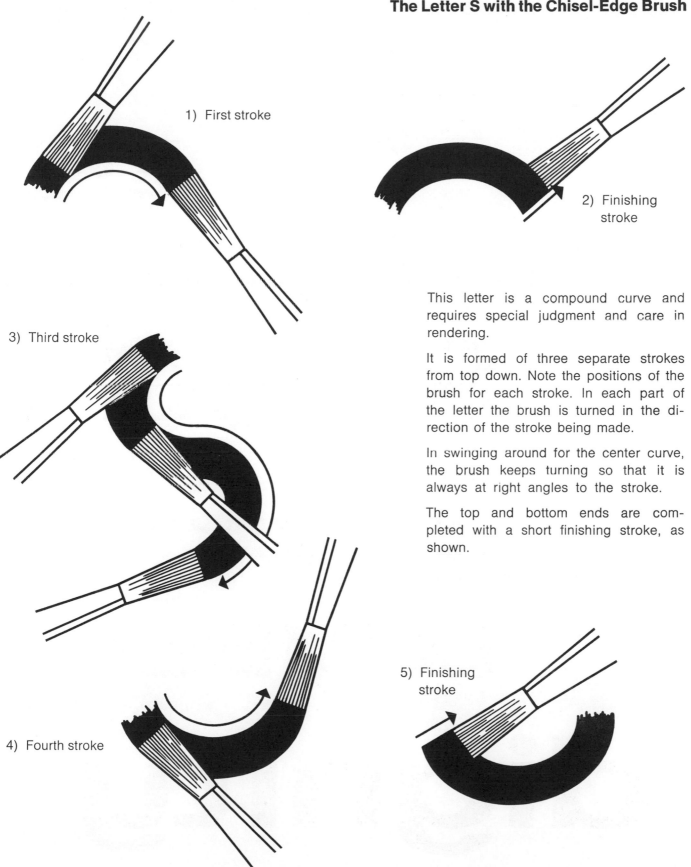

1) First stroke

2) Finishing stroke

3) Third stroke

4) Fourth stroke

5) Finishing stroke

This letter is a compound curve and requires special judgment and care in rendering.

It is formed of three separate strokes from top down. Note the positions of the brush for each stroke. In each part of the letter the brush is turned in the direction of the stroke being made.

In swinging around for the center curve, the brush keeps turning so that it is always at right angles to the stroke.

The top and bottom ends are completed with a short finishing stroke, as shown.

Going SEVENTY

Excellent examples of the Gothic style which may be rendered either single-stroke, chisel-edge, or built-up, depending on size.

in a —

pumpkin
seed

ONLY HEALTHY HANDS ARE
NATURALLY SOFT AND
LOVELY

dignity

60

This style is well suited to the chisel-stroke brush technique, as well as to the flooded-brush method.

Taste extra coolness every time you smoke.

the greatest gift going... or staying

UNDERWEIGHT PEOPLE HAVE BEEN REMEMBERED.

Observe the unorthodox combination of caps and lower case letters—avoiding the ascenders and descenders.

61

The Built-up, Double-Stroke Letter

Thus far, we have concerned ourselves with the single-stroke letter, made either with the flooded stroke or the more finished-looking chisel edge.

What happens when there is a need for a letter that is heavy and bold? Or perhaps too large for even the largest brush to make comfortably in a single stroke?

Note the example below. These letters are a good example of a bold, condensed Gothic style which can be made by a double stroke of the brush.

FRANKO for excellence
Heading DESIGN

Build the letter from left to right, so that your hand never touches a wet letter.

The round letters are treated differently, as it is essential to make both sides of a letter O before one can judge the inside strokes, which give the desired weight.

Therefore, the complete outside of the letter is made, in single strokes, before the inside is formed, as shown.

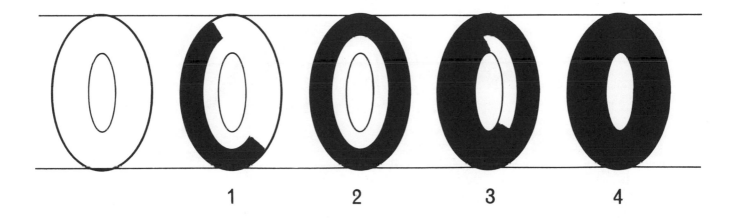

1 2 3 4

The layout or guidelines for a double-stroke letter should be complete outlines as shown (a), to allow for good form, proportion and spacing of letters.

However, many professionals will use a single skeleton guide (b), and the above elements will be amazingly correct. This kind of layout must indicate the *outside* of each letter.

Easily the most useful style of all. Its unlimited variations allow it to be used in low-key advertising as well as bold headings.

Shown here are some possible variations. Each letter represents a complete alphabet.

It may be rendered in a single or double stroke, depending on the weight of the stroke.

Because of the bulk and weight of this style, certain adjustments are essential if we are to avoid a clumsy and ungainly appearance.

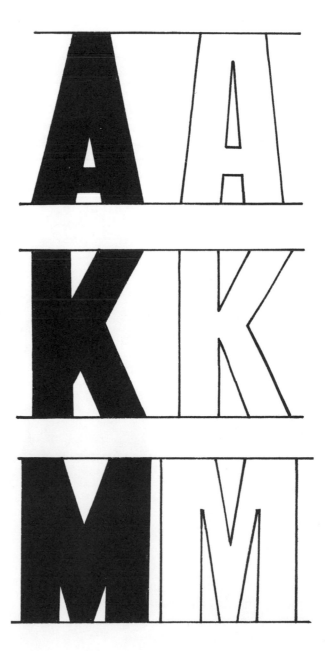

The upper part is too bulky if mechanically formed with all strokes uniform. Note how the letter becomes more open when the main strokes are altered to enlarge the center triangle.

The K is similarly changed, to reduce the black area at center and increase the white space, by imperceptibly tapering the two angle strokes.

This would be the ugliest letter of all if the strokes were made uniform. Note the two center strokes are thinned, with the tops widened. This allows the two side triangles to increase the white area.

Similar treatment for this letter opens it up considerably, making it less bulky.

Like the letter A, the two angle strokes are tapered on the inside to provide more white space.

Like the M, the thickness across the center must be reduced. We do this by thinning the two center strokes and also tapering the first and last strokes a bit.

Note the taper at the points of the two white triangles. This enlarges these triangles to avoid too much black.

Hand-lettering is not limited to the fixed sizes and proportions of type faces. The condensed form allows for unlimited variations. Whichever proportion is used as best suited to the job in hand, consistency must prevail. All letters must conform to the selected size and proportion of the basic form. Note variations below.

All strokes are uniform, with less space between strokes.

All strokes are uniform, with a space between strokes equal to (or greater than) the stroke itself.

Note the thinner strokes at top and bottom. This helps legibility when letters are very close. Lines drawn across the layout as guides will keep these strokes uniform.

67

Excellent examples of condensed letters, both in medium weight for single stroke and a heavier style (bottom), requiring the double stroke.

washes
white
SO-O

by jove,
what a safari !
WE RAN OUT OF QUININE WATER !

PUT NEW SOCK IN YOUR OLD TV PICTURE
NEW TUBE does the trick !

Examples of the varied use of the condensed Gothic style. The variation in size of the same style, used in the first example, illustrates the possibilities of this style.

THIS NEW LIGHTWEIGHT PLASTIC LETS YOU | SLIP INTO SPRINGTIME SHEERS WITH LESS WORRY ABOUT "SHOW-THROUGH"

OPAQUE **nylon** so right with sheerer fashions

Dramatic use of the condensed Gothic, in unusual layout designs.

saves work...

won't scuff !

new

HOW TO PLAN YOUR

Colorama Styling

BEAUTY WARDROBE

A most interesting arrangement of copy, with effective use of contrast in size of letters and color in reverse panel. Excellent use of the condensed Gothic.

THERE IS A man* IN your town YOU OUGHT TO know!

*YOUR INSURANCE MAN

Effective use of the heavy or very bold Gothic, in combination with the much smaller lowercase letters for contrast.

BUY FUN FOR THE KIDS !

ideal for rewards
and prizes at parties and picnics

ALL MEAT –
and packed in Glass Jars

Example of single-stroke condensed Gothic, chisel edge. Lettered in less than 15 minutes. Letter height, 4″.

This example is also 4″ high. Lettered freehand, double stroke. This style requires somewhat more careful layout.

Any letter style which has a finishing stroke other than the natural square or round end may be called a Roman style. This finishing stroke is called the serif.

These alphabets constitute the greatest variety of different styles among the type faces, and since letterers follow basic type styles while altering them to suit their needs, it may be said that the Roman alphabets in use among letterers are virtually unlimited.

Very few such styles lend themselves to the single-stroke technique, since by definition a Roman style is one that has an added stroke after the major stroke is made. Also, very few can be rendered simply by doubling up strokes as we have done with the Gothics. Here again the serif is added after the double stroke is made.

It is to be expected, therefore, that the Roman styles will take more time, and require greater effort to render, than the Gothics. However, these styles create effects not possible with other alphabets. Practically any mood can be reflected in a suitable Roman style—masculine, feminine, conservative, or very modern, to mention only a few. The variations are limited only by the imagination and skill of the letterer, and this is where the truly creative aspects of the art of lettering come into full play.

glamorous!

DISTINGUISHED COMP

POWERFULLY

Introducing

EXCITEMENT AND FLAVOR arresting

This is a freely drawn rendering of the alphabet that started it all, the classic Roman.

We depart from our policy of not dealing with historical origins in this single case, to afford students and all who may appreciate fine lettering a brief view of the progenitor of all our present-day alphabets.

It dates back before the time of Caesar; the architects and artists of the time fashioned, developed, and used an alphabet which has no peer for subtlety and beauty. Notable examples exist on the remains of buildings in Rome, and are copied, almost slavishly, on present inscriptions in stone. This was before the time of lowercase, and the original Roman alphabet did not use the letters J, U, and W. (I served for J as well as I, and V for U; K was used only in borrowed words.)

All curved letters are based on the circle, and certain modern alphabets still follow this basis. Most, however, prefer the elliptical form (higher than wide), allowing letters to be slightly compressed to save space.

Today's letterers invariably use the latter, both for space saving and ease of rendering.

For sheer beauty of form, no alphabet equals this classic Roman.

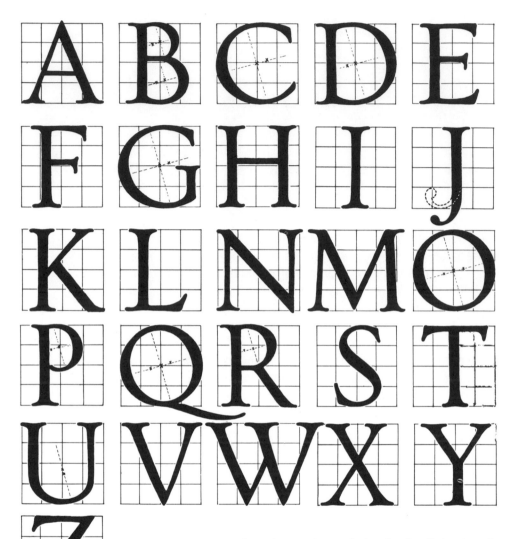

As shown here it lends itself to brush rendering, either with rounded serifs or the purer form, with gracefully tapered points for terminal strokes.

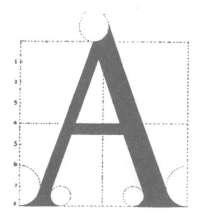

The essential difference between the Roman styles and the Gothics lies in the fact that all Roman alphabets are formed of strokes with different weights, called thicks and thins. They are a basic characteristic of all Roman styles, and most importantly, whatever the variation in style, *these thick and thin parts of each letter remain constant and unchanged.* Thus, we have a universal basis for all Roman alphabets.

ABCDEFG
HIJKLMNO
PQRSTUV
WXYZ

abcdefghij
klmnopqrst
uvwxyz

1234567890

The alphabet shown here is an effective bridge between the Gothics and the Roman styles. It contains the unadorned square ends of the Gothic while using the basic thick and thin parts, which, with serifs added, constitute the Roman-style letters.

A
B
d
m

The squared serif

The pointed serif

The rounded serif

● The Roman alphabets have two features which set them apart. One is that the letters have thick and thin parts, which may vary from a very slight difference to a sharp contrast.

● The other characteristic is the serifs, or endings found on all terminal strokes. These also vary in unlimited ways, and serve to give each alphabet an individual quality.

It is interesting to note that while you may see a very thin serif used on a heavy letter, you will rarely, if ever, see a heavy serif used on a lightface letter. This is due to the fact that a serif must never dominate the form of the letter, but must always serve as a finishing stroke to the letter style, to give the desired character to letters without interfering with their good legibility and instant recognition as letter forms.

● The serif used for any letter must also be used for every letter in that particular alphabet, including capitals, lowercase, and numerals. Under no conditions may serifs differ from each other within the same alphabet and style used.

Variations of the Roman Serifs

As will be noted here, possible variations in serif styles are limitless. Each one imparts a distinct quality to the letter, setting it apart from other styles and alphabets.

Of course, there are other characteristics which make letter styles unique, such as their weights; their shapes; their proportions and relationships to each other. These, together with suitable serifs, give each style a personality of its own.

Each Roman alphabet, therefore, will serve a somewhat different purpose. This explains the many alphabets in use, with dozens of new ones added each year.

A knowledgeable letterer will appreciate these differences and use them to make the job at hand more effective.

● Variations of hand-lettered Roman styles. Note the tasteful combination of formal script with Roman capital and lowercase.

Whatever your product...

Give it the **Beauty**

DIESEL

INCREASE the Range

PREMIUM

Masterpieces

4 pretty pastels

ROMAN

YOUNG and OLD

You are invited to try the

rich spices

Two versions of the same Roman style, with normal and extended proportions.

Note the similiarity in form, proportions, and spacing of letters.

—it gives your skin

3 WAY

BEAUTY CARE

This style is used especially for those occasions when an old-fashioned appearance in letters is desired, for testimonials, greetings, etc. It will read best when closely spaced. Avoid words with all capitals.

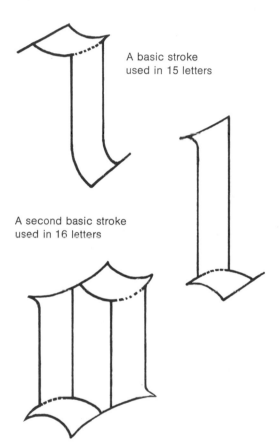

A basic stroke used in 15 letters

A second basic stroke used in 16 letters

The lowercase alphabet consists mainly of these two basic strokes which combine to form most of the 26 letters.

This style may be varied in appearance by changing the proportions to a more condensed form, closely spaced.

abcde

ITALIC: ''Designating a type style with characters that slant upward to the right.''

The straight form

The definition is by Webster and is correct as far as it goes, but it does not go far enough. It does not differentiate between letters on a slant, which are italics, and other styles which are also on a slant but are not considered italics, but scripts.

The essential difference between the italic and the script lies simply in the fact that the italic consists of *separated* letters on a slant, while the script styles (also on a slant) are letters connected by terminal strokes running into the next letter.

The true italic

Thus, we may redefine the italic as any style of letters made on a slant but consisting of separate letters. Even here, we must subdivide the italic style into those letters which are identical with the regular upright form and those wherein certain letters change form to improve their appearance. This change of form applies almost exclusively to the lowercase and not to the capitals, which invariably remain the same as their upright counterparts.

Improved italic form

Gothic regular and italic

Condensed · *Condensed*

headings · *headings*

Roman italic unchanged

Improved Roman italic— note separated letters

headings

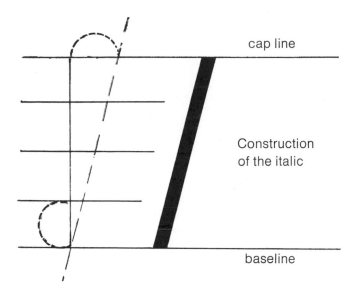

cap line

Construction
of the italic

baseline

While the slant of the italic will vary somewhat, a good standard is the 78°
angle, which is enough to accord emphasis, yet not enough to disturb legi-
bility. A quick and easy method of drawing this angle is shown above. Take
one fourth the height of the letter from base to cap line and measure this
distance to the right of a perpendicular.

The Use of the Italics

The slanted letter form is used mainly to provide emphasis to a word or
group of words. However, it must be noted that emphasis is achieved only
when and because there is a sharp contrast between the major portion of
copy and the word emphasized. Excessive use becomes self-defeating and
is to be avoided. Note examples below.

for *excellence* in heading composition

for *excellence* in heading composition

Speedball Pen Lettering

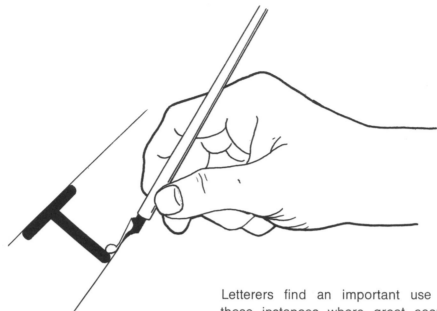

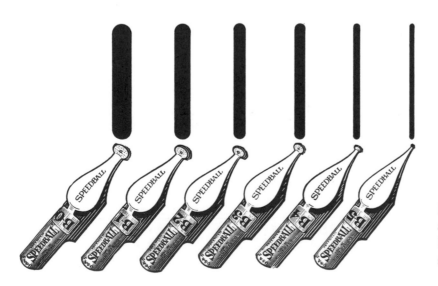

Letterers find an important use for the Speedball pen in those instances where great accuracy is not required, and where work is not intended to be reproduced. It is widely used for signs, showcards, and presentations of all kinds, including charts, graphs, displays, etc.

These pens come in a variety of styles and sizes. The most widely used, however, are the B series. These have a rounded nib, or point, which makes a uniform stroke. The writer has used these pens for letters up to 2″ in height, with effective results.

Styles of lettering are necessarily limited to the rounded stroke, with or without serifs. However, used within their limitations, they are a most effective and time-saving tool.

The B pen is made in two versions, the regular and the Flicker; this has the same point, but the ink reservoirs are hinged, flicking open simultaneously for easy cleaning.

Nine sizes are available, including B½, B5½, B6, not shown.

Clear working area. Tape job to table,
with ink and scrap paper as shown.

Place pen in holder firmly,
as far as it can go.

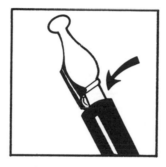

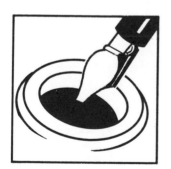

Dip point in ink bottle,
not more than halfway.

Shake pen onto scrap,
to release surplus ink.

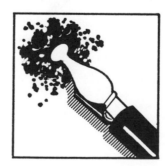

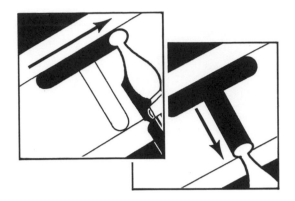

Form letters from top to bottom, and from left to right.

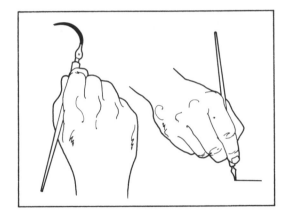

Slide entire arm when making straight or curved strokes—not only fingers.

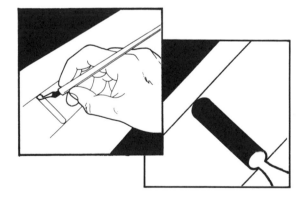

When making perpendicular strokes, start *at the line* on top, and stop at the line on bottom, not below it.

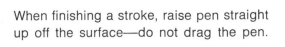

When finishing a stroke, raise pen straight up off the surface—do not drag the pen.

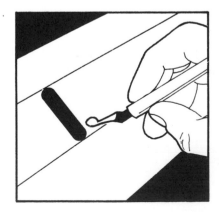

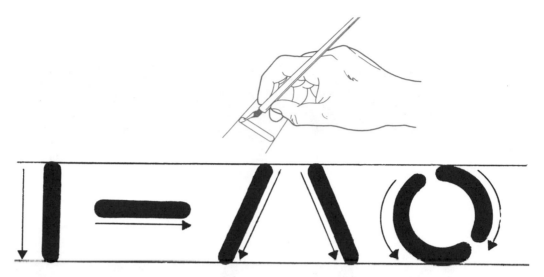

The Six
Basic
Strokes

Perpendicular and horizontal practice strokes with no. 3 pen point, ¾″ high.

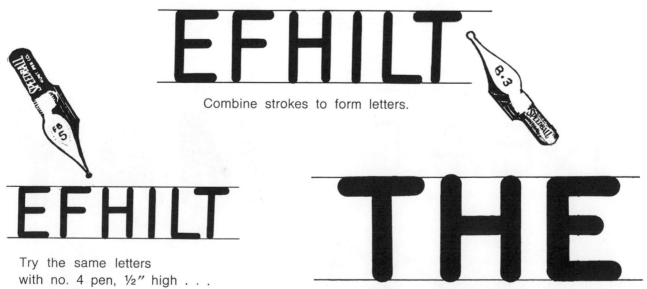

Combine strokes to form letters.

Try the same letters with no. 4 pen, ½″ high . . .

. . . then with the no. 0 pen, letters 1″ high.

The left and right diagonal strokes.

AVAVAVAVAVAVAVA

Now form these letters.

AKMNVWXYZ

Combine the perpendicular, horizontal, and diagonal strokes.

NEAT

Use no. 5 pen, ½″ high.

MAY

With no. 0 pen, 1″ high.

The curved strokes with no. 2 pen

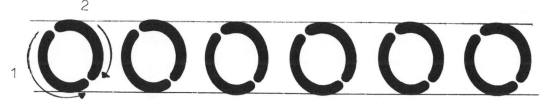

The letters with curved strokes

B C D G J P R U

S S S S S S

The three strokes to form letter S

Combining all previous strokes

FASHION

FASHION

With the no. 5 pen

FASO

With the no. 0 pen

89

CHECK LIST

○ What can <u>this</u> industry do to relieve its active and potential impact on the environment ?

○ What can it do to enhance the environment ?

○ What is being done by its most progressive elements, and what can others do, on the following fronts ?

FOR EXAMPLE:

1. Air Pollution
2. Water Pollution
3. Solid Waste Disposal
4. Noise

5. Ultimate disposition of waste from production and products
6. Plant and office siting
7. Plant and office design
8. Supplementary structures
9. Warehouse locations, appearance, traffic control
10. Trucking, distribution
11. Expansion of facilities
12. Ancillary environmental enhancement programs
13. Land restoration and reclamation
14. Use of professionals when advisable
15. Public participation in planning that might involve environmental programs

• Example of Speedball Lettering for Presentation
• Heading with brush • Overall size 30" ✕ 40"

90

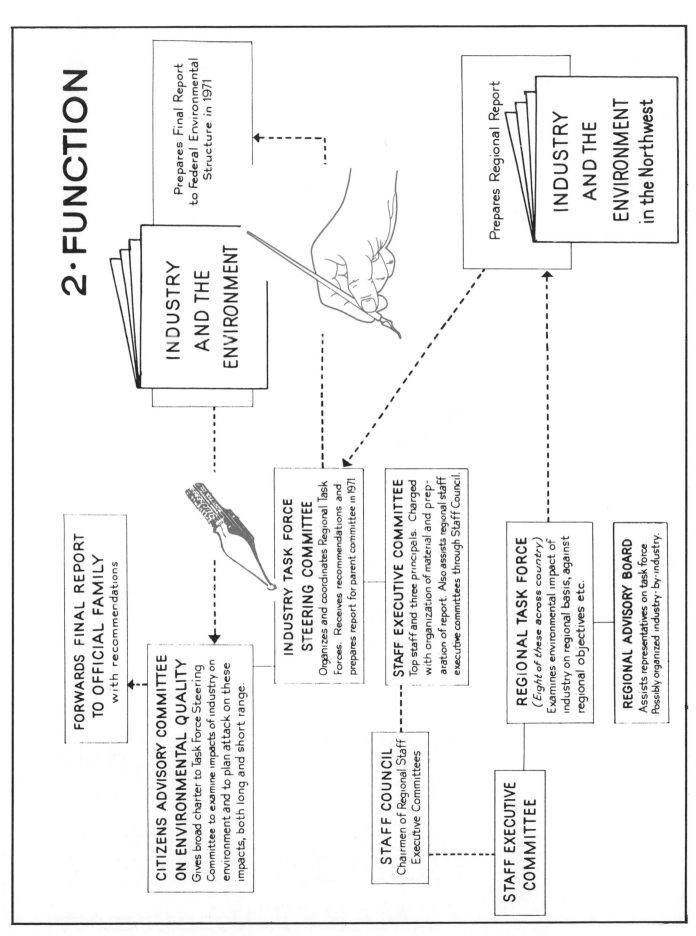

2·FUNCTION

Prepares Final Report to Federal Environmental Structure in 1971

INDUSTRY AND THE ENVIRONMENT

Prepares Regional Report

INDUSTRY AND THE ENVIRONMENT in the Northwest

FORWARDS FINAL REPORT TO OFFICIAL FAMILY with recommendations

CITIZENS ADVISORY COMMITTEE ON ENVIRONMENTAL QUALITY
Gives broad charter to Task Force Steering Committee to examine impacts of industry on environment and to plan attack on these impacts, both long and short range.

INDUSTRY TASK FORCE STEERING COMMITTEE
Organizes and coordinates Regional Task Forces. Receives recommendations and prepares report for parent committee in 1971

STAFF EXECUTIVE COMMITTEE
Top staff and three principals. Charged with organization of material and preparation of report. Also assists regional staff executive committees through Staff Council.

STAFF COUNCIL
Chairmen of Regional Staff Executive Committees

REGIONAL TASK FORCE
(Eight of these across country)
Examines environmental impact of industry on regional basis, against regional objectives etc.

REGIONAL ADVISORY BOARD
Assists representatives on task force Possibly organized industry-by-industry.

STAFF EXECUTIVE COMMITTEE

· Example of Speedball Lettering for Presentation
· Heading with brush · Overall size 30″ × 40″

A good approximation of the Roman style may be achieved with the Speedball Pen by the addition of serifs. This style is excellent in those places where more than a simple Gothic style is required.

It is important, when using this style, that words be sketched in more carefully than usual, to allow for the serifs and good spacing of letters.

Certain capitals will have a smoother, more finished appearance when their joined strokes are rounded off. This is done by forming the letter in the usual way, then briefly, yet carefully, rounding off the inside of certain serifs, as noted below:

E F L T

C G S

PATRICIA McGERR

EDWARD D. HOCH

NICOLAS FREELING

ANTHONY GILBERT

J. J. MARRIC [John Creasey]

Macy★s and save!

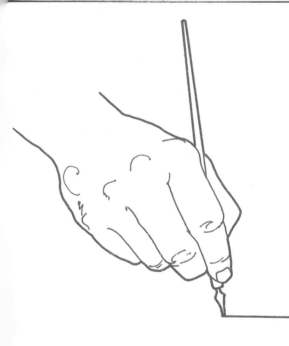

...essential
to the
Atomic Age

Legislative Roundup

Around the Nation

Calendar

HEADINGS Designed to Fit

This style, made with a point which is oval shaped, allows a thick and thin stroke. The alphabet is most useful where a characteristic Roman style is desired without the buildup or double stroke usually required. Various weights and sizes may be achieved with the assortment of pen points available in the D series.

Bold Roman-style D Speedball pen

ABCDEFGHIJK
LMNOPQRSTU
VXWYZ&JK?

7 sizes are available including the 00, not shown.

abcdefghijklm
nopqrstuvwxy
$123456789¢

The Construction of the Formal Script

A working knowledge of this style is essential to all letterers. Its uses are varied and many, whether it is merely indicated and suggested on layouts, or made rapidly with a brush on signs, showcards, displays, and presentations, or in finished form to be reproduced in magazines, newspapers, etc.

Its essential characteristic is that of dignity, elegance, and the intangible quality which comes under the heading of formal.

In spite of the seeming complexity of this style, it is possible to reduce the alphabet to basic strokes which will form almost all the letters of the alphabet. Once this is understood and a firm grasp of these basics is developed, application will be easier. These strokes are shown in detail in our study of the finished form of the script letter.

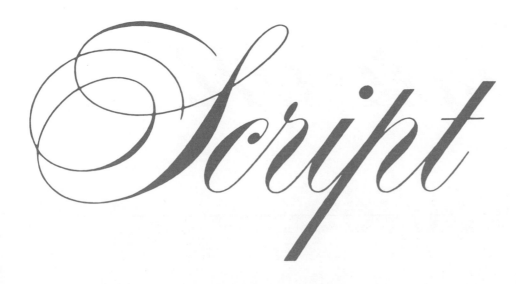

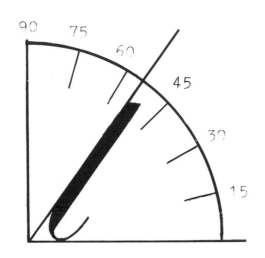

We have seen professional script lettering with slants ranging from 40° to 80°. We shall take a middle course here and use the 58° slant, which looks good and is not too difficult to render.

For practice work, place a sheet of blue-lined notebook paper over the illustration below—with blue lines matching the angle lines. Now, draw horizontal lines as shown. You should have no difficulty in maintaining a uniform slant. Trace, then copy, the skeleton alphabet on page 98, following with a more finished form.

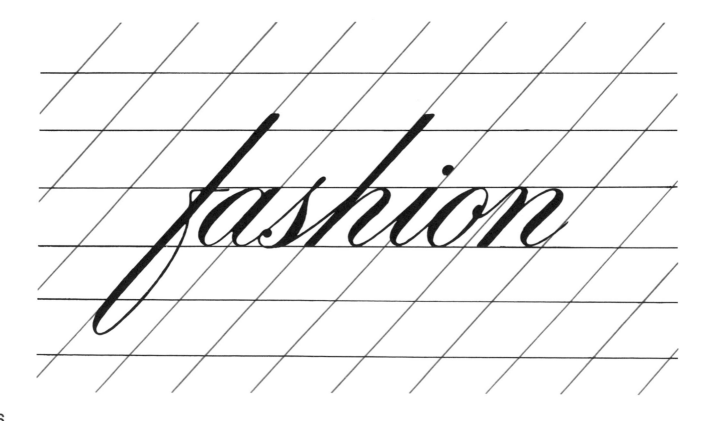

A B C D E F

G H I J K L

M N O P Q R

S T U V W

X Y Z

1 2 3 4 5 6 7 8 9 0

abcdefghij

klmnopq

rstuvwxyz

98

These will form 22 letters of the alphabet:

Cacdeggo

labdiltf

The ascenders and descenders here are larger than the body of the letter (waist to base), affording added character to this alphabet. Ascenders and descenders should never be less than body size.

1mnr

vhmnuv

wyjpr

fgjiy

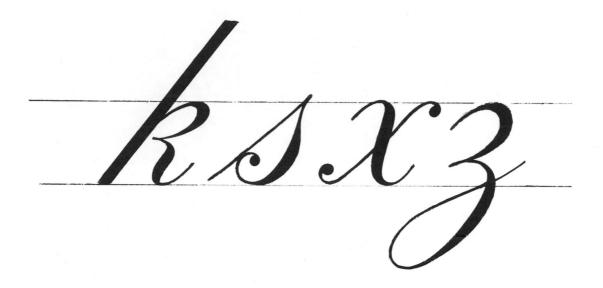

Alternate letters

These variations may be used in place of those previously shown.

Note the construction of the ascender, below.

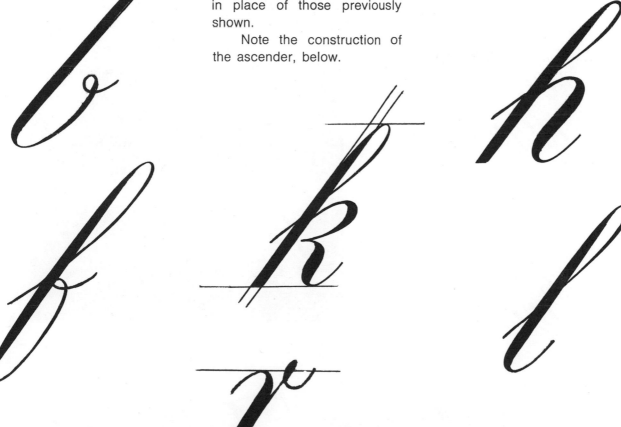

Personal Security...

Some people select gin as they do fine wines

High School of Art and Design

Hand Lettering

Lettering Inc Pen Script 3

Lettering Inc Pen Script 4

Lettering Inc Pen Script 5

Lettering Inc Pen Script 6 Light

Lettering Inc Pen Script 6 Bold

Lettering Inc Pen Script 7

Lettering Inc Pen Script 8

Modern advertising strives mightily to achieve individuality in reflecting the character of an idea. One of the most effective means to achieve this is by the use of the informal script style of lettering. Wisely used for a word or heading, it will focus attention and create a receptivity in the reader for the full message.

We may define this kind of lettering as a style wherein the letters simulate the appearance of a spontaneously handwritten message. It may be bold enough to reflect a dramatic utterance or as delicate as a whisper. It may be so freely rendered that the rules of form, proportion, and spacing are seemingly ignored. Yet in the hands of an expert, it will add a personal note that goes far to enliven a page. As the term informal implies, it conveys a feeling of casual spontaneity that is most effective.

The Informal Script

The variations are limitless, ranging from the nearly formal to the unusual and dramatic effects possible by the creative and skillful use of the many lettering tools available. These will include not only brushes and pens of all kinds, but also pencils, crayons, pastel sticks, and the many kinds of markers available today. The challenge to the lettering artist is to sense and visualize the exact style of informal script that will best reflect the thought being expressed.

It is interesting to note that the letterer will invariably spend much more time on the design and rendering of a single word of informal script than would be necessary on a comparable piece of regular lettering.

Dishes men like

The red sable rigger

spontaneity

The red sable pointed tip
for spontaneous work

The red sable pointed
tip; smaller size

the "jeune fille" look

The fountain pen for a
smooth, firm line

Now at last you can

The Osmiroid pen with
ten flat nibs

America

The grease pencil for
texture

Ink for brush or pen
Lampblack for brushwork
White for retouching

French

vellum

paper

(translucent)

Other pen points
for finer lines

GILLOTTS PENS

 #303)

 #291)

CROW QUILL

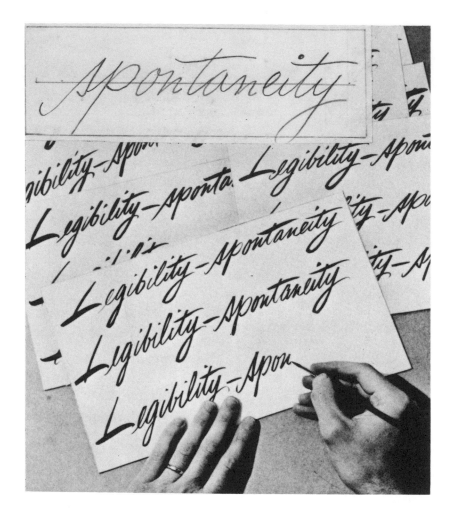

Preparation:

Set out a no. 2, 3, or 4 sable pointed brush, some lampblack and water or India ink, a supply of bond or vellum paper, some rubber cement and a pickup, and you are ready.

Step no. 1:

Draw a single pencil guideline. Now sketch the copy over this line, using utmost freedom. Repeat this until you have achieved an interesting layout.

Step no. 2:

Place your vellum over the layout (thus saving it for repetitions). Now, using a suitable size brush, with ink or lampblack, letter the copy, working freely and spontaneously. Do it over, again and again, repeating those parts or sections of letters or words not quite right. Circle and number the satisfactory sections in the order in which they appear in the layout.

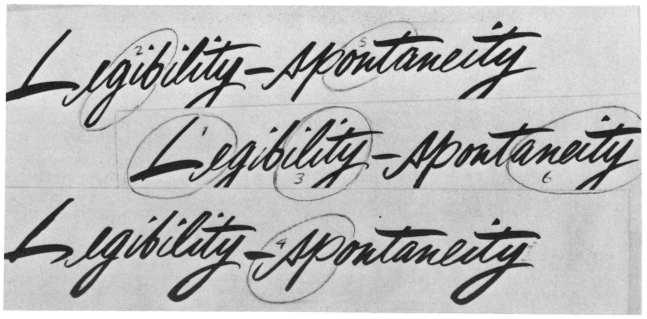

Step no. 3: Cut out the selected sections and paste them down with rubber cement. Move them about to produce the proper spacing and alignment. When dry, clean traces of cement away and retouch with black where necessary to connect letters or other places. Now use white for retouching where necessary.

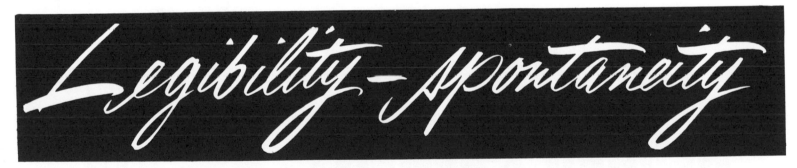

Step no. 4: For further refinement and a more exacting job, have a negative photostat made of the above. With black paint or ink, paint out any guidelines showing and make final adjustments in the lettering. Also, you may retouch with white where it appears necessary. Bear in mind this is a negative, and therefore a reverse of the original. Where a white on black surface is desired, this negative is trimmed to size and becomes the finished art. Otherwise the next step is followed.

Step no. 5: A positive photostat is made from the above negative, reverting back to black on white. Again, you may wish to make further improvements and refinements in the lettering or background with black or white before calling it, finally, a finished piece of art.

Lord & Taylor

her Charm and Grace
are made of many things

elegant...

Holiday Specials!

Drive
this
Dollar-
Saver!

Save 25%

108

fashion

All our vacation dreams
came true
it's so easy to get there
when you fly!

the land of enchantment

Long Distance

Chalk

Special savings!
23% off

The magic of
new designing

Calligraphy

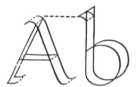

The word calligraphy means "beautiful writing," and refers to an extremely useful form of lettering which is increasing in popularity. The essential difference between calligraphy and other styles of lettering lies in the fact that calligraphic lettering is written out with a broad-edged pen rather than built up with the pointed pen or brush. It owes its style and interest to this fact.

The pen, held at a consistent angle (which varies with each letterer), makes a broad stroke when pulled in one direction. When pulled at right angles to this stroke it makes a thin stroke. The pen, then, will form a pleasing series of lines varying in thickness, according to the direction of the stroke. It is this quality of the written line, freely drawn though controlled, that gives calligraphy its charm and distinction.

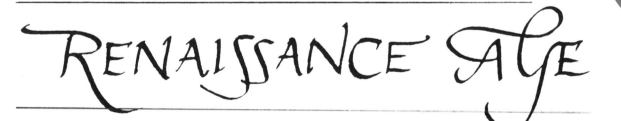

The styles and forms of calligraphy are endless, ranging from the spontaneous free form shown here to the more meticulous style of our heading In both cases the writing character of the broad pen has been maintained. The variations which result from the freely drawn letters, with no attempt to duplicate similar letters, actually add to the spontaneity and freshness of a piece of calligraphy.

However, just as we learned to write a basic alphabet in learning penmanship, to go on to our own individual styles, so beginners are advised to follow fundamental forms before attempting to be creative.

TODAY

EX LIBRIS JACK & TEDDIE WOLFF

"Recollections of Edward Johnston and Graily Hewitt"

CALLIGRAPHIC

CALLIGRAPHY

You that intend to write what is worthy to be read more than once, blot frequently: and take no pains to make the multitude admire you, content with a few judicious readers.

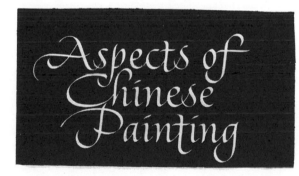

Aspects of Chinese Painting

PUBLIC LIBRARY INFORMATION

WP PRETZAT

Dr. Johnson's Dictionary

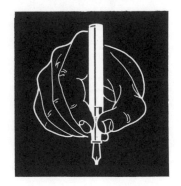

The Pens These, of course, are the basic tools. There are many kinds and styles of flat pens available today, and each comes in a variety of sizes, or width of nib.

They fall into two categories. Each has its own characteristics as to weight, length and degree of flexibility. It is essential that you find the style of pen which permits you the greatest ease in handling.

The first kind are the nonautomatic feed pens, the most popular of which are the Speedball C series, in 7 sizes. They are inexpensive, easy to use, with much flexibility. They do, however, require frequent filling and, unless the automatic feed is used, can be troublesome, since the ink flow is not controlled. Included here, too, are the steel brushes, which are flexible layers of metal, up to ¾″ wide, allowing letters up to 6″ high. Other nonautomatic pens are shown, each with qualities of their own. It is advised that you obtain one of each make and find which suits you.

The automatic-feed fountain pens have the big advantage of controlling the ink flow, so important in any work requiring uniform strokes.

The Osmiroid pen is an automatic feeder, and is useful to those preferring a short nib and an edge that is not as sharp as the Speedball nib.

The Pelikan Graphos has a longer and more flexible nib than either of above, with a very thin and sharpened edge. It is easy to clean due to a swivel-edge top layer.

The Platignum is the most popular of the fountain pens for lettering calligraphy. It lies midway in length and weight, with a well-sharpened edge, in a variety of widths up to ⅛″, which allows for a letter one inch high.

It will be necessary for the serious student to experiment with all or most of these pens before finally settling on the pen and holder which are most comfortable in your hand.

Pens specially designed to reproduce the italic style of handwriting:

Speedball Lettering Pens

Speedball Steel Brush

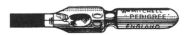

Mitchell Round-Hand no. 0

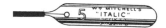

Mitchell Italic

Osmiroid Broad Oblique

Pelikan Graphos Pen

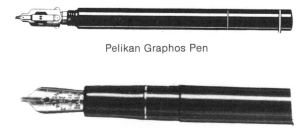

Platignum Broad Italic

Higgins
Pen Cleaner

The Inks Manufacturers of pens usually make their own inks. It is advisable to be guided by this as the feeds in the various pens are not alike. Generally, bear in mind that the nonautomatic pens will take the waterproof inks, containing carbon, which will clog the automatic or fountain pens. Here, use the nonwaterproof inks, which are dyes, and thin.

The paper Should be smooth without a gloss. A good bond or bristol will serve. Always have a larger sheet of smooth board under the paper for firmness and resiliency.

Miscellaneous items You will need a T square, a 60-30 triangle, a 4H pencil, a kneaded eraser.

Drawing Board Work on a board tilted to a 45° angle. The writing sheet is not taped or pinned down, but held in position by a guard sheet as shown.

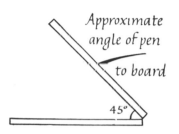

Approximate angle of pen to board

45°

The T square slides along the left edge of the board for making the horizontal lines; vertical lines are made by sliding the shortest leg of the triangle along the horizontal of the T square.

Posture Sit upright, with both hands and forearms resting on your desk or board. Your paper should be straight in front of you, so you can judge the verticals better. When doing an italic style, it may be easier to tilt the paper slightly to left.

Paper

Guard sheet

Pen and Finger Position Hold the pen lightly between thumb and first finger, with second finger giving it support. The pen will then lie naturally on the side of the first finger in line with the top knuckle (a).

(a)

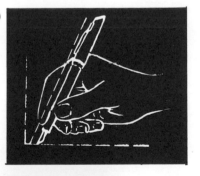

For Left Handers

Make sure you use the oblique nib. It also helps if you keep your elbow close to your body, with pen pointing over your shoulder. Place your writing paper over to the left of center, at a sloped position, as shown.

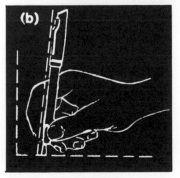

(b)

Incorrect

Italic calligraphy

We refer here to lettering made on a slant as compared to calligraphic lettering made with perpendicular strokes. It is important to differentiate between the two styles since the pen angle is not the same for both. Another term for the italic style is cursive, or rapid personal handwriting made with the broad pen. This presupposes a knowledge of the basic forms.

For our purposes here, we shall be using the Platignum lettering pen, with the assorted nibs shown. The ink will be a nonwaterproof India ink.

Fine straight Medium straight Broad straight Fine oblique Medium oblique Broad oblique Left hand fine Left hand medium

SILVERLINE PEN
This pen has pressmatic filling. Unscrew barrel and squeeze filler bar. Immerse nib in ink and release pressure on filler bar keeping nib immersed for 5 seconds. For maximum fill repeat two or three times. Wipe nib and replace barrel. Wash pen occasionally by repeating filling action with luke warm water. Do not use waterproof India ink in a fountain pen.

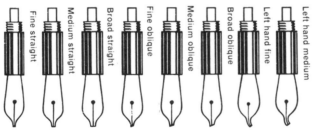

What soever

thy hand findeth to do,

do it with all thy might

The Pen Angle

The pen is held at a constant angle of 45°.

The Letter Slope

The slant of the italic is slight—not more than 5° to 10° at most.

		Ascender Line
$2\frac{1}{2}$		Cap line
$2\frac{1}{2}$		Waistline
5	*Rhyme*	
		Baseline
$2\frac{1}{2}$		
$2\frac{1}{2}$		Descender Line

The height of lowercase letters from waistline to base is made 5 times the width of the pen nib or stroke thickness.

The ascenders and descenders are of equal height to above.

The capitals are made 7½ pen widths, or half again the height of lowercase. They are smaller than ascenders, and this is characteristic of calligraphic lettering.

A B C

D E F G

H I J K

L M N

O P Q
R S T U
V W
X Y Z

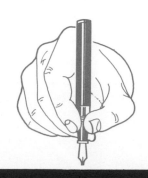

A B C D E F G H I J K
L M N O P Q R S T U
V W X Y Z 1 2 3 4 5 6 7 8 9 0

FLOURISHED CAPITALS AND NUMERALS

Controlled flourishes are permissible but do not attempt these until you have first mastered the basic alphabet.

The quick brown fox jumps

FELICITATIONS

over the lazy dog : pack my

This perpendicular form is in contrast to the italic. The style shown here is based on a height of 7 times the weight of a stroke for capitals, and 4½ for the body of the small letters, with ascenders and descenders 2½ widths. This makes the ascenders equal to the capital letters.

These proportions are not rigid and may vary somewhat with the style and model.

The angle of the pen point is kept at a constant 30° for the perpendiculars. The diagonals will require a 45° angle.

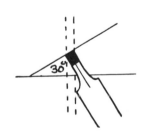

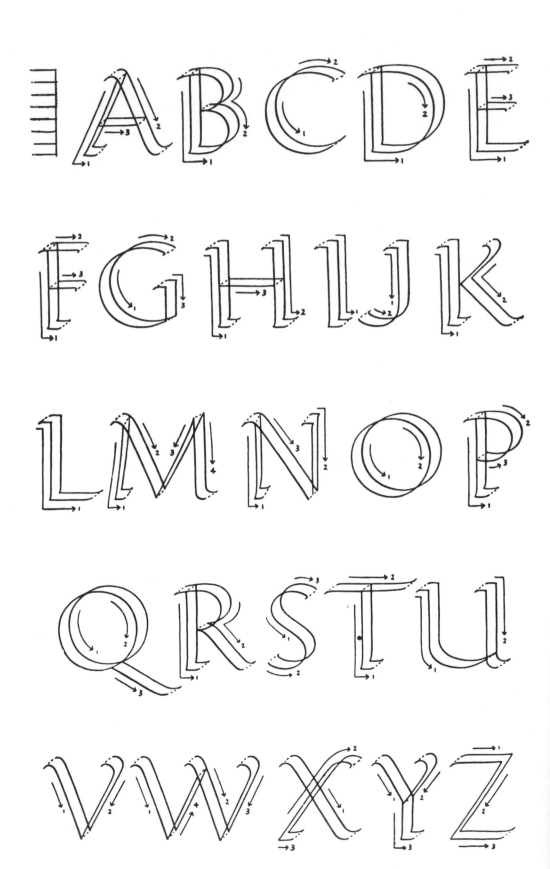

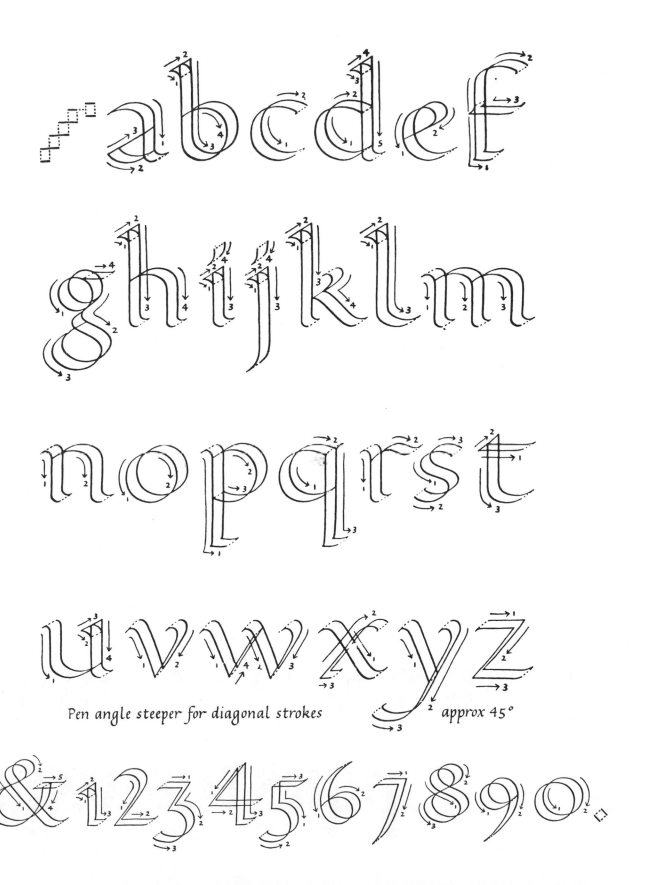

Pen angle steeper for diagonal strokes approx 45°

Combining caps and lowercase in a single calligraphic alphabet, this style has many uses and is easily adapted to the broad pen or brush for easy and rapid rendering. Shown here are three different proportions. Note the informality of a lowercase in its decorative ascenders and descenders.

The normal proportion

ABCDE

The extended

ABCDEFGHY
KLMNOPQR
STUWXYZ

ABCDEFGHYKLMNO
PQRSTUVWXYZ

The condensed

THE HIGH SCHOOL OF ART & DESIGN

A Commentary on Some Recent Advances

Lettering Inc CALLIGRAPHIC

Love is something sweet and something sad. It has
its gaieties and its ironies; it has its smiles and
its tears. It happens not to genius only, it is droll
more often than it is sublime. It is something
as simple as sunlight and spring, as dusk
or autumn. The familiar love songs of mankind

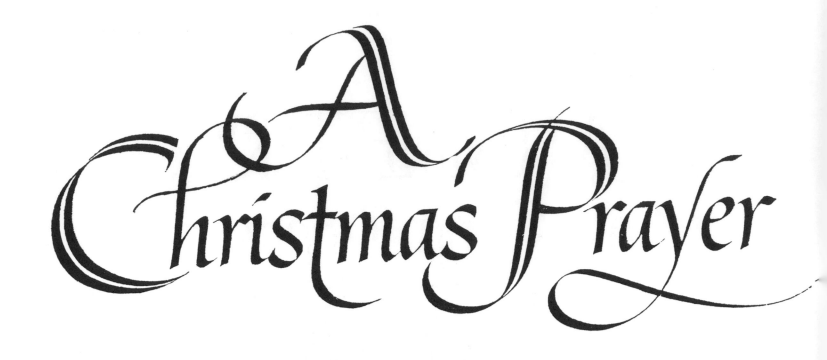

A Christmas Prayer

Containing favorites of the past 100 years from Turgenev to Thurber, from Balzac to Hemingway with biographical sketches by

extends

best wishes

for a

prosperous

new year

Best Wishes
for Christmas
and the
New Year

chisel point

There is an urgent need in every advertising studio for lettering on layouts. There are more letterers at work in this area than all others, and in places that handle much daily retail advertising, as department stores, a crew of letterers is constantly kept working at the indication of type on layouts for the daily pages of newspapers. These are the specialists in the most widely used lettering tool—the chisel-point pencil.

Since these letterers are invariably indicating type faces, it is essential that they become familiar with most current styles of type, so that they may render a specified typeface easily, quickly, unmistakably.

Layouts are almost never reproduced as final art. Their degree of finish will always be less than that of finished art and will range in accuracy and detail from the very rough of a retail layout, to the near finished state of a comprehensive layout for an expensive magazine advertisement.

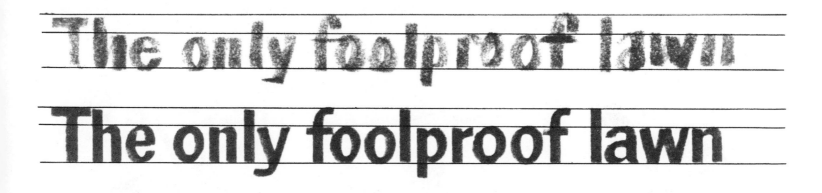

The major copy on these layouts is hand-lettered with the chisel-point pencils. This means the use of various drawing pencils, sharpened and fashioned to the shapes of chisels, affording broad, flat strokes to easily form the thick and thin parts of the Roman styles or the uniform thickness of the Gothic alphabets.

In addition to the pencils shown, you will need the ruler, T square triangle, kneaded eraser, single-edge blade, sandpaper block, and visualizing pad.

Useful types of pencils for chisel-point lettering:

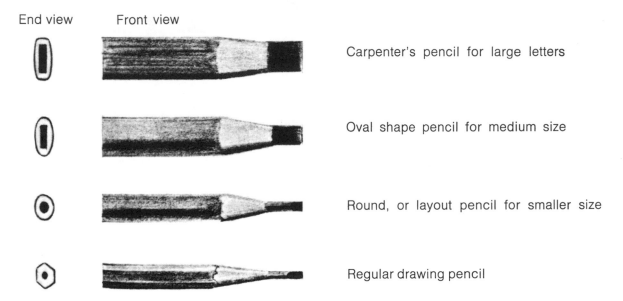

End view Front view

Carpenter's pencil for large letters

Oval shape pencil for medium size

Round, or layout pencil for smaller size

Regular drawing pencil

These pencils may be obtained in varying degrees of lead. Most useful for layout work is 2 or 4B.

To Sharpen the Chisel-Point Pencil

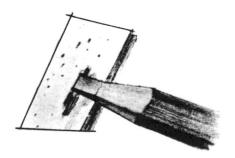

1 Begin by first cutting away the wood with a blade or knife.

2 On a sandpaper block sharpen the lead to the width of the broadest stroke you will require.

3 Rub both large flat sides to a chisel edge. Square the end by holding pencil straight up on the block and rubbing lightly.

The six basic strokes
of the alphabet:

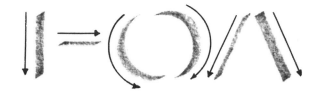

The basic
STROK

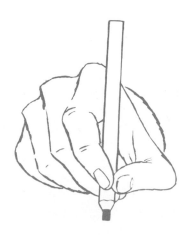

Always hold the pencil so that the chisel point forms about a 30° angle with the horizontal guideline.

Sit comfortably, work on a firm surface, and hold the pencil as you would to write.

Keep your pad straight on the board to judge verticals better. Sharpen your pencil often on the sandpaper to maintain clean, sharp edges.

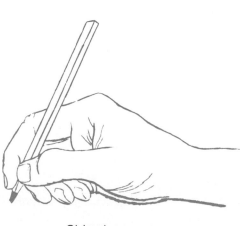

Side view

Front view

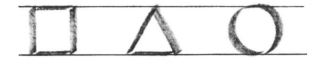

1 Keeping your chisel point at a 30° angle, draw a square, triangle and a circle.

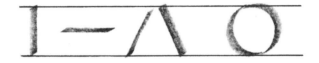

2 In drawing the above, you have formed the six basic strokes comprising the alphabet.

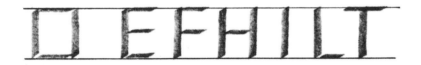

3 The vertical and horizontal strokes will form these letters.

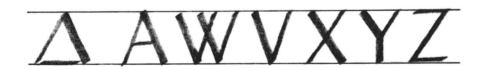

4 The triangle gives you the diagonals of these letters.

5 The circle is the basis of these letters.

The letters not shown—B, D, G, J, K, M, N, P, R, U—are formed by combinations of the above strokes.

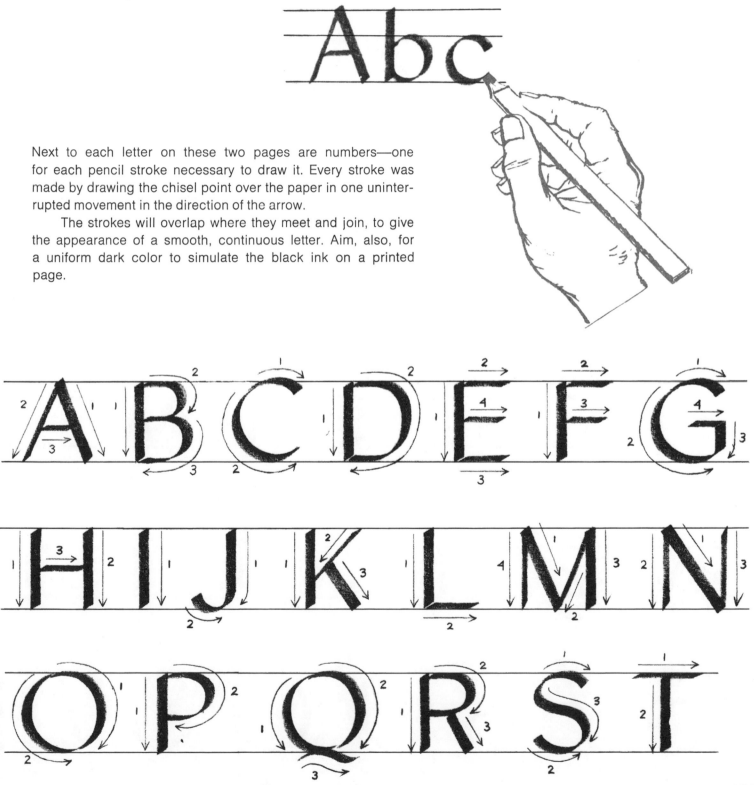

Next to each letter on these two pages are numbers—one for each pencil stroke necessary to draw it. Every stroke was made by drawing the chisel point over the paper in one uninterrupted movement in the direction of the arrow.

The strokes will overlap where they meet and join, to give the appearance of a smooth, continuous letter. Aim, also, for a uniform dark color to simulate the black ink on a printed page.

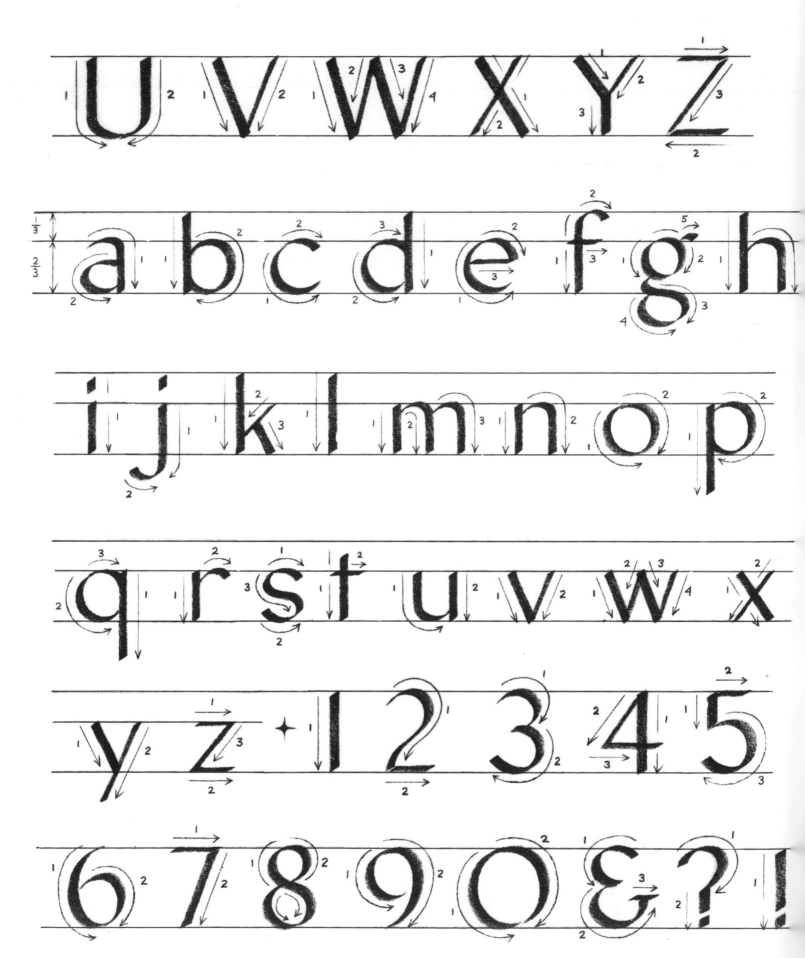

130

As stated, advertisements invariably use typefaces for their headings. The letterer, working on layouts, must be able to render the essential character of any typeface, with the chisel-point pencil, in such a manner that his rendering will be unmistakable in style, character, and appearance on the layout. All this must be done easily and quickly. He may take liberties without changing the character of the style he is indicating.

To maintain the essentials of any typeface:

(1) The weight of the strokes must be very close to the actual type style.

(2) The character of the form, which sets it apart from all others, must be indicated clearly, though not accurately.

(3) The color must be dark and uniform in tone to approximate the printed page.

This is
a printed
Caslon
letter.

This is the
basic form
without the
serifs.

Add the serifs
for a pencil
indication of
the Caslon.

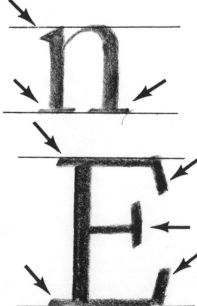

Making serifs: The arrows point to the serifs, each of which is made in a single stroke. These serifs are not identical with those of Caslon type, but with the weights and forms otherwise followed, the essential character of this style is maintained and easily recognized.

This family of alphabets has strokes which are basically uniform in thickness. The pencil must be sharpened to width of broadest stroke. Where stroke is wider than pencil will permit, then double stroking is used.

The pencil is always turned in the direction of the stroke being made so it will have uniform width, except in those details which are somewhat narrower in width to avoid unsightly weight.

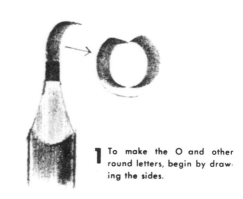

1 To make the O and other round letters, begin by drawing the sides.

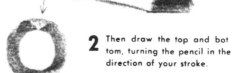

2 Then draw the top and bottom, turning the pencil in the direction of your stroke.

ABCDEF

GHIJKLMNO

PQRSTUVWXYZ

1234567890&!?

abcdefghijklm

nopqrstuvwxyz

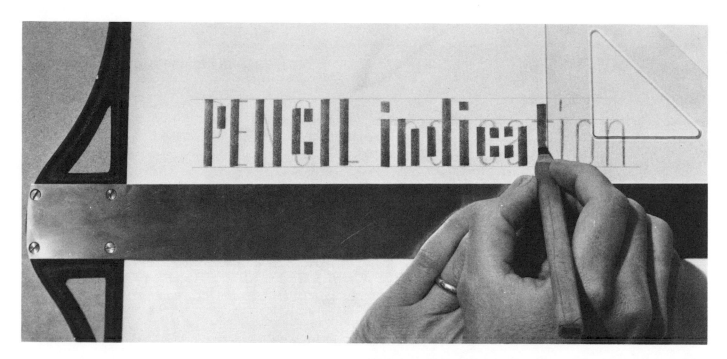

To draw the Gothic letters, use the edge of the T square and triangle as guides for the horizontals and verticals, then draw the curved strokes freehand, keeping the pencil turned in the direction of the stroke. Square the edges of the verticals and horizontals by stroking them with pencil against the T square. These letters can also be drawn freehand. In any case, a skeleton guide is advisable.

ABCDEF GHIJKLMNOP

QRSTUVWXYZ&

1234567890 !?

First draw the verticals with the T square and triangle, then join them with freehand curves.

Generally, the curved stroke is thinner and tapers where it joins a straight one, as in the R, h, and n.

abcdefghijklm

nopqrstuvwxyz

How rough or finished your pencil lettering should be depends upon its use. It can range from the very rough to the extremely refined.

The first Rough:

The only foolproof lawn food! new Golden Vigoro

The Rough: Generally made by tracing over the first rough sketch to afford a better idea of the weight of the lettering.

The only foolproof lawn food! new Golden Vigoro

The Semirough: A further degree of finish. Most advertisers will be satisfied with this kind of type indication.

The only foolproof lawn food! new Golden Vigoro

The Comprehensive ("comp"): This degree of finish affords a very clear idea of how the finished ad will look in print.

The only foolproof lawn food! new Golden Vigoro

Practice different size letters. Use harder pencils as the sizes get smaller

and always keep your chisel point sharp for crisp letters.

Sketching pencil

Layout pencil

4d drawing pencil

HB or B drawing pencil.

Also practice letters with narrow strokes and **wide strokes**

The letterer must be prepared to render any style, any size, weight, or proportion.

Learn to use the most suitable pencil for the job at hand.

Lightface

Medium weight

Boldface

Extended face

Condensed face

COLOR IS IMPORTANT

The color of this line of copy is good because the letters are uniform, well spaced, and of same value.

135

Below we have set a piece of copy in three different faces and sizes; a small, light face, a medium size and weight, and a larger, heavy face.

Notice in each case how different the type looks and how much more space it occupies as the size of the type increases. Under each block of copy we show how to indicate it on the layout. Double lines are the most widely used. Note how thin lines, with only a small amount of space between them, were used to indicate the light face, and how the lines are made heavier and the space wider as the size and weight of the type increased.

The line indication of type must approximate the overall color value of the body of type. A good rule of thumb here is to draw a line which is equivalent to the weight of a single stroke of the type being indicated. In all cases the lines should be black, simulating the black ink used on a printed page.

The lines used to indicate copy on layouts should express the value and the size of the type. This is done by giving the lines the correct weight and by ruling them the correct distance apart. Use dark lines for boldface types and lighter lines for lightface types. To indicate type with more space between lines, draw your lines further apart. Here you see the same copy set in three different type faces and sizes with different line spacing or leading.

The lines used to indicate copy on layouts should express the value and the size of the type. This is done by giving the lines the correct weight and by ruling them the correct distance apart. Use dark lines for boldface types and lighter lines for lightface types. To indicate type with more space between lines, draw your lines further apart. Here you see the same copy set in three different type faces and sizes with different line spacing or leading.

The lines used to indicate copy on layouts should express the value and the size of the type. This is done by giving the lines the correct weight and by ruling them the correct distance apart. Use dark lines for boldface types and lighter lines for lightface types. To indicate type with more space between lines, draw your lines further apart. Here you see the same copy set in three different type faces and sizes with different line spacing or leading.

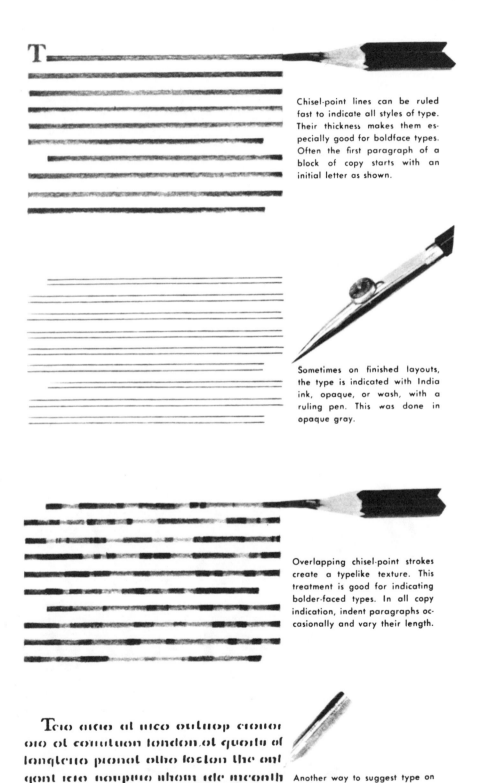

Chisel-point lines can be ruled fast to indicate all styles of type. Their thickness makes them especially good for boldface types. Often the first paragraph of a block of copy starts with an initial letter as shown.

Sometimes on finished layouts, the type is indicated with India ink, opaque, or wash, with a ruling pen. This was done in opaque gray.

Overlapping chisel-point strokes create a typelike texture. This treatment is good for indicating bolder-faced types. In all copy indication, indent paragraphs occasionally and vary their length.

Another way to suggest type on very finished layouts is by a series of vertical pen or pencil lines, broken by a few horizontals and curves. Occasionally put in ascenders and descenders, and space your "words." This technique is called "Greeking."

The Tools and Methods of Lettering
for Reproduction

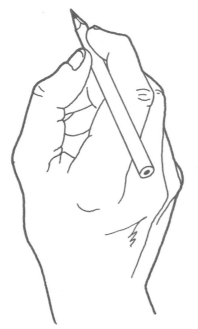

Even though the availability of photolettering—with its thousands of hand-lettered alphabets—has cut into the need for hand-lettered headlines, it is essential for the letterer to be familiar with the technique of finished lettering.

By finished lettering we refer to lettering intended for reproduction on the printed page. This requires a degree of finish that is very exacting.

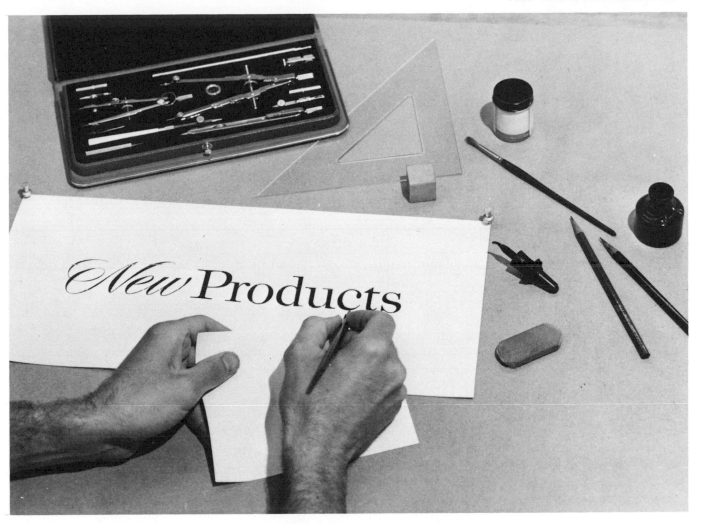

The tools and materials listed previously for doing script brushwork can also be used for doing finished lettering. However, because of the exacting nature of this work, the fine pen points are best for rendering.

The most popular lettering pens are: Gillott no. 290, which has a fine point and is flexible, making it useful for scripts; Gillott no. 170, which has a medium point and is more rigid; and Gillott no. 303, which is a slightly thicker, even more rigid pen. Of course, the crow quill will make the finest line of all, but this pen line must never be reduced in reproduction.

A good ruling pen is a must, as is the bowpen (compass for ink). You will find much use for a quality set of mechanical drawing instruments.

You will need a no. 2 or 3 sable brush of best quality for retouching with white. Have another for use with black.

Any good black India ink will serve for use in pens. Extra-dense ink is best for brushwork since it covers better.

For retouching, use an opaque white watercolor such as Permo, Luma, or Pro. You will also use lampblack where it is necessary to retouch over white.

Most finished lettering is done on kid-finish bristol board, three-ply. You may prefer the plate-finished surface and should experiment with both.

While finished lettering may be done in any size convenient to the letterer, it must be kept in mind that when finished work is rendered smaller than reproduced size, requiring enlarging, much detail will be rough and fuzzy. Any line which is sharp to the eye tends to become rough when enlarged. Usually, letterers will work one half larger than reproduction size. The reduction of the original will then tend to sharpen all details. The following, however, is twice as large as final, not "½ up."

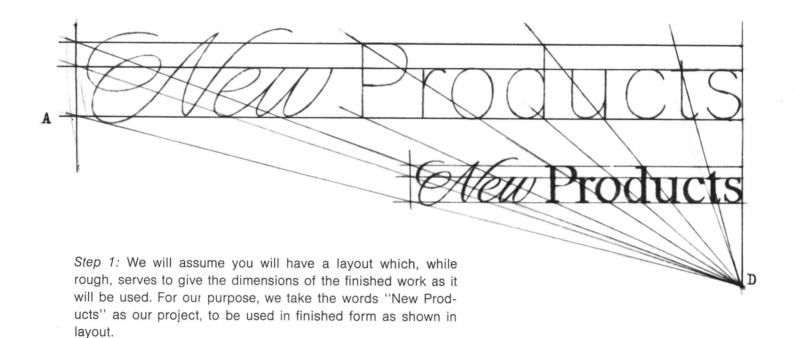

Step 1: We will assume you will have a layout which, while rough, serves to give the dimensions of the finished work as it will be used. For our purpose, we take the words "New Products" as our project, to be used in finished form as shown in layout.

We proceed to enlarge the layout to a more convenient size for ink rendering, while keeping the larger dimensions in proportion to the original layout. We call this procedure "scaling up," and follow these steps:

(a) Rule the three guidelines on the layout lettering, and tape a piece of tracing paper over it.

(b) Draw perpendiculars through the right and left ends of the layout, extending the right one upward and downward. This is the right end of both layout and rendering.

(c) From this right upward extension, draw the baseline for the rendering, making it twice as long as the layout baseline.

(d) Draw a line from the left end of the rendering baseline through the left end of the layout baseline until it meets the right perpendicular below the layout. This is point D.

(e) Extend lines from D through the left ends of the other 2 lines of the layout. This establishes the waist and cap lines on the rendering.

(f) Locate some of the letters, such as P, d, and t, by drawing diagonal lines through these points. This will give you a good start for your enlarged layout.

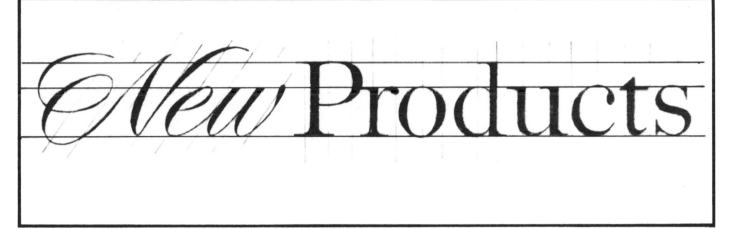

Step 2: Blocking in Now slip your enlarged layout under a sheet of visualizing paper. Stroke in the letters with a chisel-point pencil. Establish form, proportions, weights, and spacing of letters. Do not try for accuracy of detail here, but rather for an overall appearance of the letters.

Step 3: Final drawing of letters Refine the letters with pointed pencil. Make necessary adjustments in details and check for flaws.

Register marks

Register marks

Step 4: Preparation for tracing When satisfied with above, turn over and blacken back with an H pencil. Face up, tape layout to board surface, using register marks as shown. (Register marks are used so that tracings or other overlays are positioned exactly in the same place each time.)

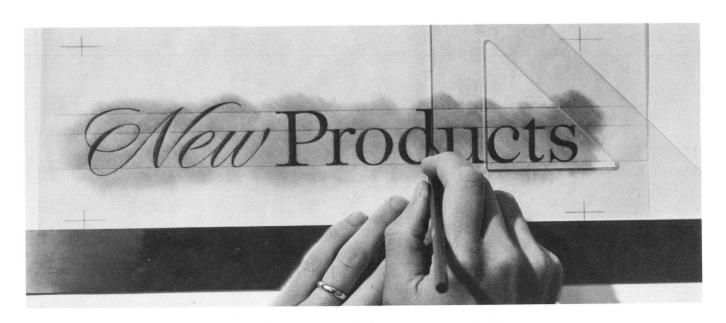

Step 5: Tracing down Using a 6H pencil, with the aid of the T square and triangle, trace all vertical and horizontal lines of the letters. By removing the drawing paper (bristol) from the board, leaving the tracing attached to the drawing paper, you may turn the paper to whatever angle is best for you to complete the freehand tracing. Keep the pencil sharpened while you work.

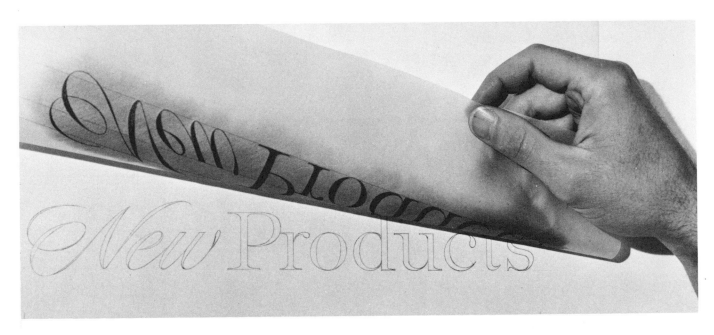

Step 6: Check your tracing As you trace, frequently lift your tracing paper to see if the lines being transferred are clean and sharp. Make firm lines but do not press so hard that you create furrows in the paper. The more precisely and accurately you do this the easier and more successful your inking will be.

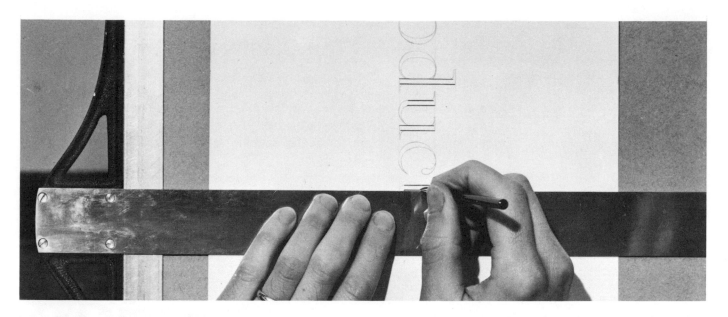

 Step 7: Inking the verticals and horizontals With a T square and triangle, and using a ruling pen, draw all the straight lines. Fill in with a pen or brush. You may also prefer to draw the strokes with a freehand stroke if they are not too large.

Step 8: Inking the curved letters Free your paper from the board when inking curves, so you can turn the paper and make the strokes in the direction most convenient to you, which will usually be toward you—right to left or top to bottom. Use a sheet of paper under your hand to avoid smudging. Keep pen clean and wipe it often.

Step 9: Finishing touches Retouch only after all inking is finished. Make corrections with a pen where possible. If necessary, use opaque white with no. 2 brush on the black. Correction of black over opaque white can be done with lampblack and a brush—not India ink. Examine your work from every angle for small flaws.

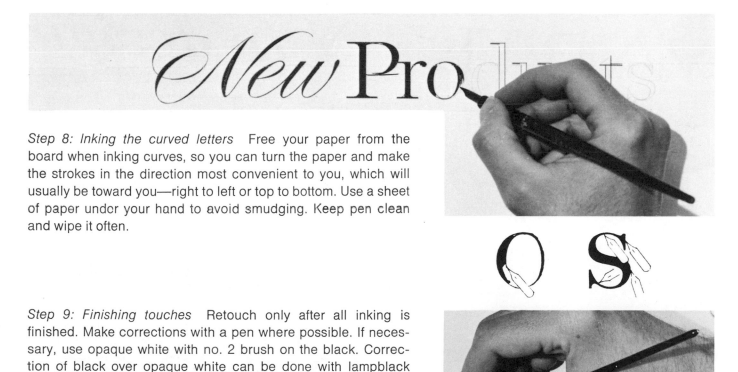

The Creative Use of Lettering

Examples of the many ways in which a word or phrase may be treated for various effects. Note that in all cases the fundamentals and principles of good letter form, proportions, and spacing are closely observed.

VARIETY in design

Variety in design

VARIETY *in design*

Variety in design

VARIETY IN DESIGN

VARIETY in design

Variety in design

In each case the subject or mood is expressed by an appropriate style designed expressly to illustrate the thought.

Whispering Leaves

A suggestion of leaves has been worked into the capitals with delicacy and restraint. When you use designs in letters, be careful not to overdo it lest the design overpower the letter.

COLOR

The animated decorations suggest color. The shadow on the right and lower sides of the letters defines their forms.

CAMAY—*The Soap of Beautiful Women*

The trade name is both bold and feminine — bold because of the heavy strokes and feminine because of the light serifs and thin strokes. The script makes a welcome contrast and emphasizes the delicate feminine nature of the product.

Power

The letters are heavy, forceful ones. They are arranged on a slightly curving line and linked, which suggests determined movement.

SCULPTURE

The shadow effect gives these letters a three-dimensional appearance, like raised letters carved on a stone monument.

Jazz

Like jazz music, the letters here are bold and vigorous in design and are spaced and staggered in an unconventional way.

Chanson

In this stylized interpretation of feminine handwriting the letters are varied in width to give a change of pace.

SURF

The black lines serve the decorative purpose of imitating the movement of the surf. At the same time they give the letters originality.

Country Carousel

The words suggest gay, old-fashioned doings — so the choice of these old-fashioned letters was a happy one. The big outlined C's add excitement, as does the flowing curve of the words.

Lotus PUMP

The lettering had to be feminine — yet bold enough to stand out on a page. A form of broad-pen lettering was used with a flourish to the L. "Pump," done in Bodoni-like lettering, accentuates the slant in "Lotus."

HAUNTED HOUSE

Sign Painting and Showcard Writing

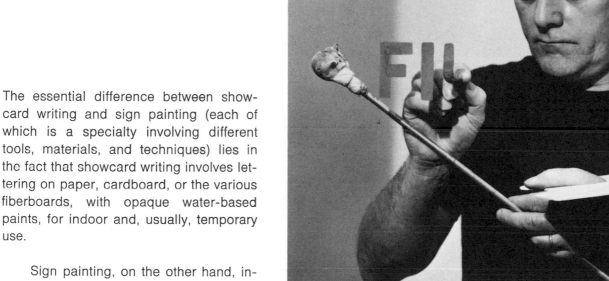

The essential difference between showcard writing and sign painting (each of which is a specialty involving different tools, materials, and techniques) lies in the fact that showcard writing involves lettering on paper, cardboard, or the various fiberboards, with opaque water-based paints, for indoor and, usually, temporary use.

Sign painting, on the other hand, involves lettering on paper, wood, cloth, metal, glass, plastic, etc., for outdoor and more permanent use.

Wood palette

To withstand weather and abuse, oil-based paints are used, with brushes designed to hold the oil paints and especially made for sign painters' use. The best brushes for lettering with oil paints are those known as camel hair, even though no brush was ever made from the hair of the camel. Camel hair refers to various types of soft hair other than sable or ox hair. It has a high gloss and is quite springy, which makes it very useful for lettering on glass or other smooth surfaces with oils or japans (oil paints with an additive to hasten drying). These brushes are soft and silky, with very fine hair, and carry the oil colors much better than the coarser sable or ox hair, and so are preferred by most professional sign painters.

Palette cups

Since most of the sign painter's work is done on surfaces which cannot be laid flat, he or she letters in an upright position. For balancing his brush hand he will use a mahlstick, which is simply a rigid pole or rod made of wood or metal, with a soft tip attached for resiliency and comfort while moving the brush (see illustration).

In metropolitan areas, the sign painter and the showcard writer are recognized as separate specialists, and only rarely will one man qualify as expert in both techniques. In New York City, the union representing sign painters and showcard writers has a different pay scale for each specialty.

Aluminum
mahlstick
(12″ sections)

The Brushes for Sign Painting

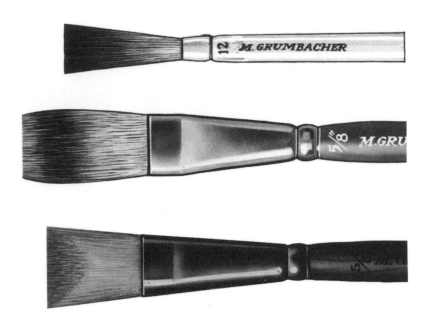

The lettering quill Made of camel hair with graduated hair lengths and widths. Best for clean, sharp work with japans, oils, enamels, and similar paints.

Single stroke Made of camel-ox mixture. Natural-tip hair cupped to square, straight edge. Sizes up to 1½". Best for coated wood and metal surfaces—trucks, for example.

The sign fitch Used by billboard and wall painters. Ideal for use on metal and stone surface, with bulletin oil paints. Sizes range from ¼" to 2".

The Paints for Sign Painting

In using paints for sign-painting purposes, it is important that they be made for lettering. There are two major manufacturers of such paints, the Ronan line and the popular 1 Shot lettering colors. Both makers carry the three types of paint generally used.

First, the poster colors, which are waterproof and suitable for interior signs of a semipermanent nature. They dry quickly to a velvet-smooth, flat finish. Thin with mineral spirits.

Second, the widely used 1 Shot lettering enamels. Superior flow assures absence of brush marks. Dries to a high gloss; fade-resistant. Thin with turpentine.

Third, the bulletin paints for maximum outdoor durability. Best for lettering on billboards and other outdoor spaces on brick, cement, or metal surfaces.

All of the above are sold in 1-lb. cans, in a wide range of colors.

These paints dry quickly to a lustrous, waterproof finish for woods, metal, glass, acetate, or paper.

Gold and Silver Enamels

148

Examples of Lettering on a Truck and an Outdoor Billboard

Variations of Lettering Position on Flat or Upright Surfaces

Overhand method

By resting one hand on the other you can swing the brush freely. No part of the letter is hidden from view as you form it.

Free-arm method

For large letters which are pencilled out first, this method is useful. A yardstick or mahlstick can be used to guide the brush hand in making the long straight strokes.

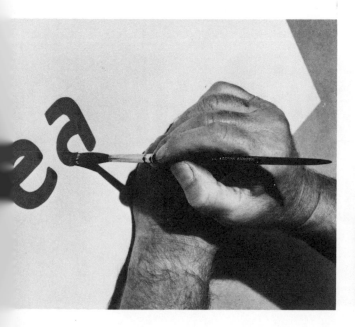

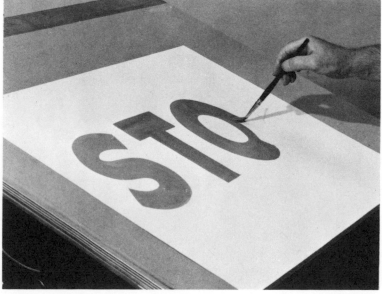

These are widely used in retail shop windows. White translucent paper is used, available in rolls 12″, 18″, 24″, 30″, and 36″ wide. It is advisable to use a quick-drying oil paint called japan for the lettering, with camel-hair quills, to avoid wrinkling of the paper, which occurs when lettered with water-base paints. Opaque paper up to 8′ wide, in light and dark tones, is obtainable for indoor signs. These may be lettered with sable brushes and poster paints.

The illustrations show window display signs. Made on paper, they avoid blocking out the light from the inside, and can be made any length.

Showcard letterers refer to their work as "showcard writing." The term is an apt one, for an experienced showcard letterer is so skillful and fast that he seems literally to write his signs. There is a wide market for his skill. Nearly every store in every community has a need for showcards and signs of various kinds. For anyone who letters well, this can be a good way to add to his other income—and it can be developed into a profitable business with a relatively small outlay of capital.

Tools and Materials

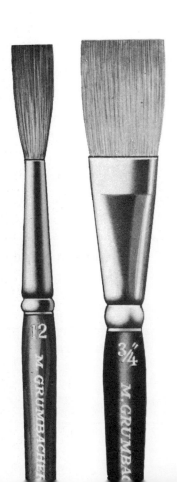

Most showcard writers prefer to work standing at a waist-high table with the top slightly tilted. A regular drawing table can be adjusted to serve very well. There should be a wood or metal strip along the front edge projecting at least a half inch above the surface, to keep the cards from sliding off. This also serves as a support for the T square when needed. See the arrangement of materials on the table or board on page 38.

The showcard brushes

Generally, two types of brushes are used. The most widely used is the rigger, a red sable lettering brush with a round ferrule and square-cut edge. Riggers are obtainable in 16 graduated sizes or widths, and short, medium, or long hair lengths. The widths vary from ⅛" to 1". When charged with paint they spread somewhat. In expert hands they are very flexible and easily form either uniform strokes or the variations of thicks and thins required in making the Roman or script styles.

There is also the flat single-stroke brush, so called because the flat ferrule makes the brush tend to keep a uniform thickness of stroke more easily than the flexible rigger. It too is made of red sable, with square, straight edges in graduated sizes up to 1½". Most useful in forming letters of uniform strokes.

Both types of brushes are best for water-base paints.

The Showcard Paints

These tempera, showcard, and poster colors are fine-quality opaque watercolors. The brilliant colors are smooth-flowing and flat-drying, and will not chip or rub off. They are finely ground for lettering and come in 2-oz., ½-pt., pint, quart and gallon sizes. The range of colors is excellent, with over 40 different colors available.

It must be remembered that these paints are water-soluble and must be kept covered when not in use.

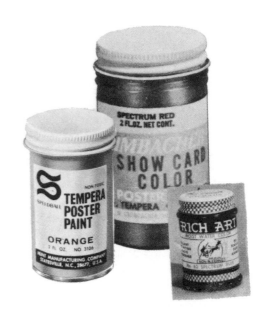

For Special Effects

Poster paints in brilliant daylight fluorescent colors. They glow as if lighted from within in a dark area. They are opaque tempera colors and can be diluted with water, yet are waterproof when dry. Made in a range of colors.

Acetate inks are drawing inks for use on any type of plastic sheet. They will not spread or creep, and work in a pen or brush. They can be removed with a moist cloth. 9 opaque colors in 1-oz. bottles.

Lettering Surfaces

Showcards are made on a variety of surfaces, including paper (both translucent and opaque), cardboard, and the fiberboards such as Foamcor and wallboard. The most common is cardboard, which comes in many colors and takes poster paint or India ink easily. The full sheet is 28″ × 44″, which can be subdivided into stock sizes as shown. It is made in single or double weight—14 or 28 ply. Also available are colored sheets 40″ × 60″. For larger sizes the fiberboards are made in 4′ × 8′ sections. Poster paints may be used on all surfaces for indoor use, except the translucent papers—see notes on paper signs.

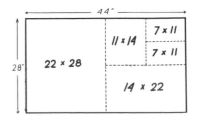

This type of work must be done quickly and easily. For this reason, the Speedball pen, with its choice of four different point styles, is the most popular among professionals. Speedballs are inexpensive and easy to use, and in the hands of an expert, the results are effective.

The inks used are of two types. One is the transparent waterproof for white surfaces, in 18 colors, and the other is the nonwaterproof, pigmented, opaque ink for colored surfaces, in 12 colors.

These fountain pens and markers are useful to the sign writer. Your supplier will have folders on the best uses of each.

Osmiroid pens

Platignum pen

Pelikan Graphos pen

Flair/El Marko
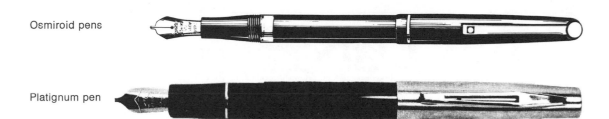

An imported drawing ink fountain pen that has interchangeable nibs to provide widths of line ranging from 0.1 to 10mm and in six different styles.

Illustrator permanent-ink fine-line pens

A permanent ink fine line marker for paper, film, plastic, cloth, metal, etc. Has a Dacron tip for easy flow of ink. Ink is odorless and non-toxic. Available in four colors each color-coded for easy identification.

Pentel sign pens

Rich Art gold and silver inks

The Pentel gives you the speed and response of a felt marker in a pen. It has a special firm tip that combines the best qualities of a ballpoint and a felt marker. The tapered tip allows you to draw a fine line or a broad stroke. The Pentel is ideal as a marker, a sketching pen or for lettering signs.

Shown here are a few of the many pens and brushes available to the show-card writer, with examples of the kinds of letters they are best suited for. Not included are the fountain type lettering pens, nor the wide variety of markers suitable for lettering. These are shown on other pages. Manufacturers usually furnish booklets explaining the use of their products; these are obtainable from suppliers.

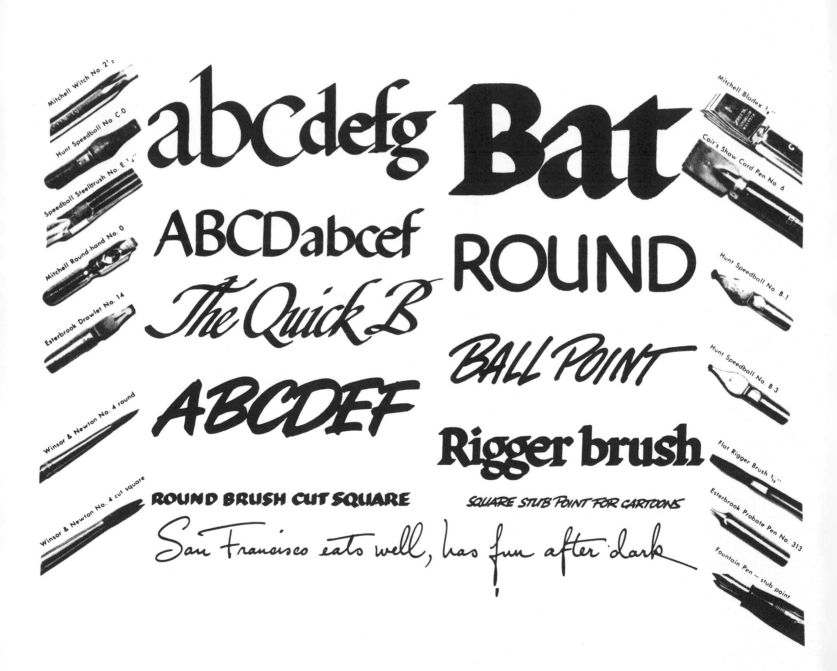

REAL
ESTATE
OFFICE
★
RENTALS

Examples of fast freehand lettering with brush and pen, suitable for today's displays of all kinds.

Sugar
supplies
ENERGY

satisfies your
appetite!

5 treats a week
for breakfast

There's
Nothing
like a
New
Car...

Rock 'n' Roll
Rhythms?

NOW

More examples of lettering with brush and pen for showcards and displays.

NEVER
BEFORE
POSSIBLE..

FOR THE CONVENIENCE OF THE PUBLIC, THE BANKING HOURS OF THIS OFFICE ARE 10 A.M. TO 6 P.M. MONDAY THROUGH FRIDAY.

The Magic ink pad
That Never-Ever runs dry

EASY- DRAW, FULL
TOBACCO **flavor**
WITH THE TRULY PROTECTIVE FILTER

Knitwear
in the world's finest cashmere

in half the time

156

The Popular Cartoon Style

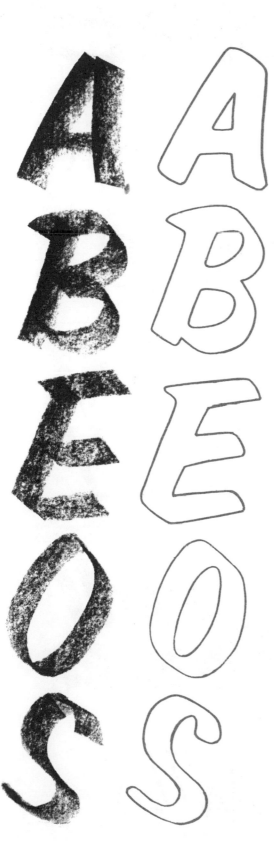

The essential character of this style is that of a spontaneous, freely drawn and rendered letter which imparts an informal and attention-getting quality to a word or phrase.

It has a calligraphic character in that its strokes are formed by the natural pressures of a flattened brush. The vertical strokes of the italic form (which is most commonly used) will begin or end with a rounded point touching the top or bottom line. The curved strokes will tend to be flattened at an angle, with the inside forming a clean ellipse, as it would be when formed with a flattened brush held at an angle.

To construct this style:

An effective way to draw this letter is to use a section of charcoal or pastel cut to the width of the stroke desired. With the flat edge, draw the strokes as shown here. Create a ribbonlike effect with strokes overlapping.

The first version will be somewhat stiff and unfinished, but should indicate the major parts of each letter and provide for the spontaneous effect essential to this style.

The second version, drawn directly over the first, will be in outline form, wherein the strokes are refined to allow for tapered strokes and the subtle curves which give this style its essential character.

After this, you can easily paint the letters by filling in the outline, or, when you are more familiar with this style, paint the letters directly with a flattened brush or marker. When completed, check the letters for a retouch of details where necessary.

This is an essential style in every letterer's skills with a wide range of usefulness.

Varied examples
of the cartoon style
in action

BAB

TASTE

SNAP! POP!
CRACKLE!

FIRST AND
FINEST...

NOW

*ELECTRIC
BATTERY*

**Full
Power**

lettering!

WAXTEX

YOUR NEW

ABCDE
GHIJK
LMNOP
QRSTU
WXYZ

The minor inaccuracies which may be noted (such as non-alignment, variations in the weights, etc.) are not only tolerated but welcome, since they add to the spontaneous and nonmechanical character of this style.

abcdefghi

jklmnoprs

tuvwxyz

123456789

Lettering Inc Brush Style 41
Brush Style Lettering

HEADINGS Designed

A light-faced version, extended and condensed made on the vertical rather than the usual italic.

HEADINGS Designed

HEADINGS Designed

Similar in form to above, with double strokes for thick parts. Note the non-alignment which adds to informality.

HEADINGS Designed

HEADINGS Designed

A freely rendered version of the extended italic form.

HEADINGS Designed

Similar to above with serifs added. Note separation of letters due to serifs.

HEADINGS Designed

Each stroke is a double one with concave sides and white retouching for added effect.

Brush / Medium

Thick and thin parts are formed with flattened brush to impart a bouncy yet readable effect.

Frisket (Stencil) Cutting

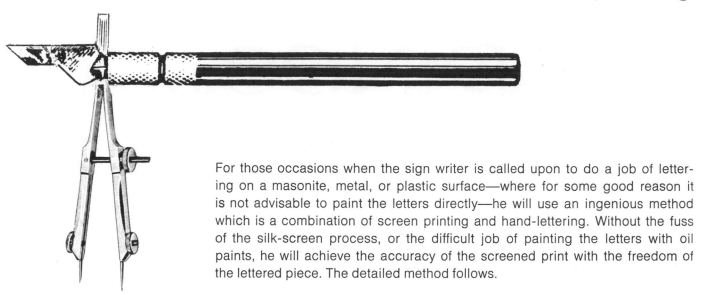

For those occasions when the sign writer is called upon to do a job of lettering on a masonite, metal, or plastic surface—where for some good reason it is not advisable to paint the letters directly—he will use an ingenious method which is a combination of screen printing and hand-lettering. Without the fuss of the silk-screen process, or the difficult job of painting the letters with oil paints, he will achieve the accuracy of the screened print with the freedom of the lettered piece. The detailed method follows.

Step 1: The Preparation of the layout

The design, letters, or layout are first made with a well-sharpened HB pencil, accurately and full-sized, on a translucent white paper. This pencil layout becomes all-important. Care must be exercised in developing the letters or design to the point where the lines are clean and accurate, with proper regard for letter forms, proportions, and good spacing. Do not expect the finished work to be better than this pencil layout. Use straight edges and compasses where possible for greater accuracy. The completed pencil outline should be thin, clean, and accurate.

Step 2: Adhering layout to surface

After layout work is completed, check final surface for cleanliness. Wipe with damp cloth and dry well. Now, placing layout in position (by matching top horizontal with previously drawn horizontal guide on surface), fasten paper to surface with masking tape along top edge. Flip paper over and crease along tape edge. Now coat back of paper with 75% solution of rubber cement thinned with Bestine. Allow 5 minutes for absorption; then, starting at right side, press layout to surface with ruler or piece of card, easing it into place, working from top down, until entire layout is smoothly adhered. If layout is more than two feet long, it may be slit vertically in two (after taping) for greater ease in adhering. Allow sufficient margin on paper for protection when letters are sprayed.

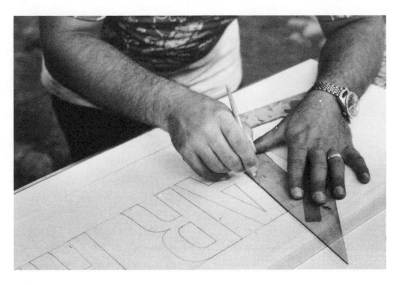

Step 3: Cutting the stencil

Using a good film stencil knife (e.g. X-acto no. 1, with blade no. 16), cut the letters or design to be painted. The knife must cut into the background to be painted, but lightly. Too deep a cut may show after the spraying—and one not deep enough will make for rough edges when removing paper. You must develop a light, firm touch with the knife. Use a straight edge as a guide for straight letters and the bow compass cutter for circles or curves wherever possible. They make the job of cutting easier, faster, and more accurate.

Step 4: Stripping the letters or background

After stencil is cut completely, you will remove those parts which are to be spray painted. This means either the individual letters, leaving the center sections (as in the O), or the background around the letters, if the background is to be sprayed with the letters remaining covered. Do this by inserting the knife edge, *not the point only,* under a section of the paper, and lift off as much as you can in single strips. Strip carefully, and follow the contour of the design where possible.

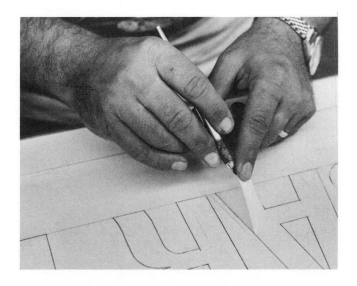

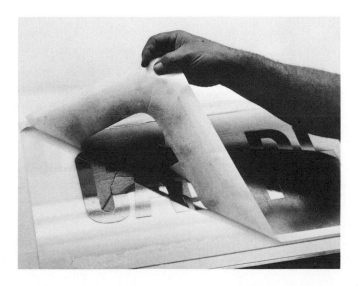

Step 5: Spraying letters or background

In preparing for the spraying of paint, see that all traces of rubber cement are removed. Use a rubber-cement pickup, but avoid marring the ground. On outdoor signs, or other designs which are coated with a lacquer paint, a similar paint should be used for the spraying. For the spray gun, the paint is somewhat thinned with lacquer thinner. Avoid a heavy deposit of paint, which builds up around the edges of the stencil and causes a rough edge when the paper is lifted after spraying. Two coats of a thinner paint are better than a single heavy coat. It is always safer to use the same kind of paint in spray painting as for the background, to avoid chemical reaction between different paints.

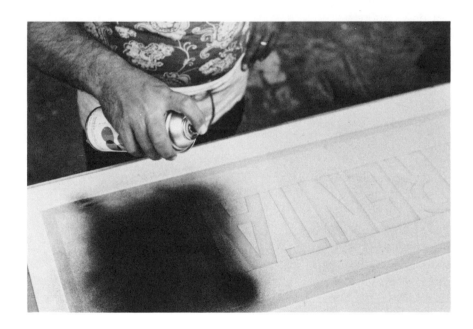

Where a translucent effect is desired on a plastic surface (partial light shining through), apply one thin coat, and when semidry stipple: press the surface lightly with a ball of cotton covered with cheesecloth until surface is uniform and semitransparent.

Step 6: Final Stripping

After spray coat is dry, remove the remaining sections of stencil as in Step 4. On oil or lacquer surfaces, final stripping is best done when sprayed paint is nearly dry, rather than hard dry—to avoid paint breaking under stripping. After all paper is removed, clean surface of rubber cement. The job is now complete.

Section of finished job, with letters cut, stripped, and sprayed.

CAR RENTALS

CAR RENTALS

Section of finished job in reverse. Letters cut, background removed and sprayed.

The final appearance of the finished frisket job will depend on the ability to handle a cutting knife—to make round strokes that are smooth, or straight strokes that do not waver.

For those who have difficulty in making an accurate drawing of letters suitable for cutting, it is advisable that they make a photostatic enlargement of a suitable typeface; a tracing can then be made on the paper used for the stencil.

THE NEWEST LETTERING TOOL

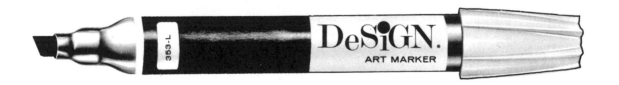

THE MARKERS

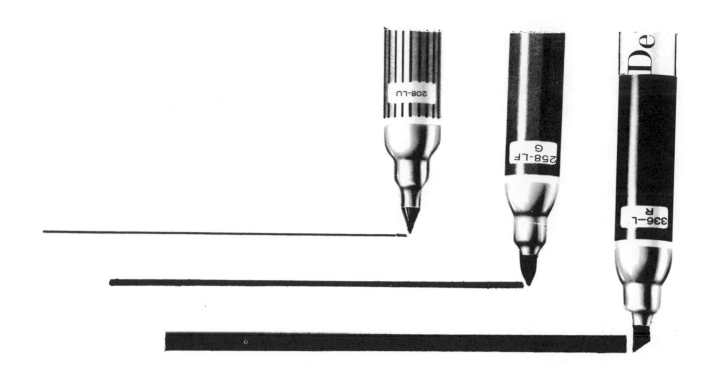

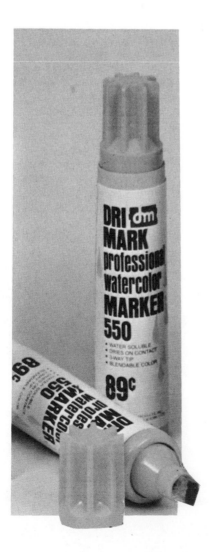

Markers of one kind or another have been around for years, but with the development of new materials and nibs, they have become an important and valuable tool for lettering artists. They are used for all kinds of layout and design work, sketches, signs, posters, presentations, dummies, and other advertising purposes where accuracy is not essential but where speed and ease of handling is important. As such, they are truly indispensable.

There are definite limitations in their use, the most important being the fact that they lack opacity. This means that light colors cannot be used on middle or dark backgrounds. But working within their limits, they are a most useful lettering tool.

There are many manufacturers of markers, and basically they have much in common. For letterers, it is important to know that three points are available—the fine line, the medium point, and the broad nib, here illustrated. These three points will vary somewhat with the different manufacturers.

For versatility and practical usefulness it is important that one become aware of the various makes, sizes, colors, and nibs available, and that a good variety of these markers be kept on hand.

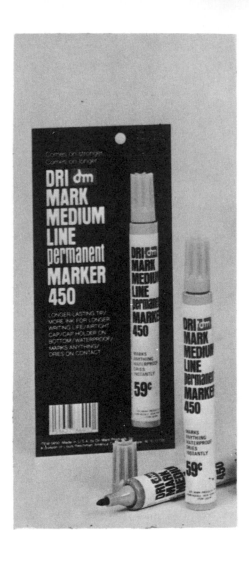

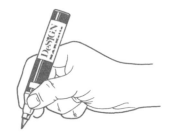

MAGIC MARKER STUDIO FLOURESCENT MARKERS

Made with Day-Glo® pigments in 8 dazzling colors—Blaze Orange, Saturn Yellow, Neon Red, Signal Green, Arc Yellow, Rocket Red, Fire Orange, and Aurora Pink

Dri Mark®
Nylon Tip Markers write more than a mile

Write on any surface with thin line stroke.
100% nylon tip.
Smearproof.
Handy pocket clip.
Cap color shows ink color.
dm Item 400

This is Spray Mark. Magic Marker makes it for people who think big and have to cover large areas with beautiful, transparent Magic Marker colors. Like a point-of-sale piece, a full size poster, a packaging design or mock-ups for same.

It works on any surface — including glass, paper, foil, metal and plastic. And you can mix colors by overspraying.

It comes in 36 colors that match our markers.

Spray Mark can be removed from non-porous surfaces with a damp cloth or fixed permanently with our UVA fixatifs.

UVA FIXATIFS

Protects art work from smearing, as well as colors from fading.
CRYSTAL CLEAR or MATTE FIXATIF

PERFECT FOR FINE LETTERING SKETCHES AND WRITING

- Brilliant watercolor
- New Nylon Tip discovery
- Writes—without pressure
- Extra fine line
- Writes sharp, clear—everytime
- Tip stays sharp—won't mush up
- Cap with clip is color coded

A freely lettered Gothic cartoon style using two sides of a broad nib to obtain thick and thin strokes with a single stroke of marker. This requires a high degree of professionalism.

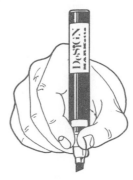

THOMAS INTERNATIONAL

An excellent example of a single-stroke cartoon style made with a medium-weight pointed nib.

Two fine examples of single-stroke lettering, actual size, made with the fine-line and medium-point markers.

Both examples would be done easily within 15 minutes by an experienced professional.

REGISTRATION

your badge, proceed

directly to the Show

...fill-in card and

present to cashier

Q. *Where and by whom are markers used for lettering?*

A. Markers are used by professionals and amateurs alike in many and varied places. The pros use them for sketches, lettering, and layouts of all kinds. They are widely used in the presentation field for quick and easy lettering on paper and board in place of brush or Speedball pen. They are widely used for making signs and showcards and other window announcements. In every parade or group protest you will see markers used to make the signs of protest. They are used in schools of every kind for the above types of work. Also, in school, they are widely used for audiovisual presentations and for overhead projection purposes. Basically, they are used wherever anybody wants to say something and wants it to be read loud and clear, and with a minimum of effort on the part of the user.

Q. *Which are the best surfaces for each type of marker?*

A. The most commonly and widely used markers are the broad nibs (professional jargon for the chisel-tip nib), and the felt tips, in quarter-inch width. This type of nib will apply to any surface, because it is a wide nib and can take much abuse. On poster board which has two sides, one which has some porosity and one which has a varnish finish, the ink will show up better on the varnish finish but may take a little longer to dry because of the lack of porosity. On the side which has the porosity, it will dry and get into the paper much faster. Basically, with the types of markers that are on the market today, a white background should be used because the markers are made of a nonopaque transparent type of ink and the colors would not show if they were used on colored papers. For instance, a red will never show on a black background. A green on a dark-blue background would not show as green. So to show two colors of markers the white background paper should be used.

Q. *What about acetates—will any marker take well?*

A. No, not every marker will take well on acetates. Acetate has no porosity and acetates are used mainly for audiovisual presentations and in schools for overhead-projector use. Teachers like to use the acetate over and over again, and there is a special marker called the "overhead transparency marker," a water-base marker. It is different from the ordinary water-soluble marker, will work on a transparency, and will wipe off easily with a damp cloth. Advertising agencies or commercial art studios sometimes like to make permanent presentations on acetate and overlays, and they use the permanent-ink markers, which take very well on the acetate, but are much, much harder to take off it. They can be removed by using a vegetable oil such as Mazola or Crisco, because the marker, having an oil base, will mix with the oil and the ink can therefore be removed.

Q. *The nibs—how do they vary and what is the best use for each (size, shape, etc.)?*

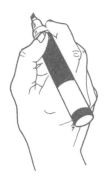

A. The most popularly used nibs are nylon, acrylic, or porous-tip markers, which are used for writing and which can be used in sign making by outlining letters, words, or figures in the fine-line and then filling in these letters, words, or figures with a wider-nib marker. For signs, the quarter-inch or felt-tip marker is the best one used. There used to be a half-inch-wide marker on the market but that one is very hard to find today. One marker that is available has a half-inch-square nib, which can be used for lettering. The best size and type of nib to use for making signs is the quarter-inch-wide felt nib. The plastic-tip nibs are practically the same size as the nylon or acrylic nibs, and are basically writing-instrument nibs. There is a nylon-tip, medium-size nib, made by Dri-Mark, which can also be used for lettering. These are made with permanent ink.

Q. *The nylon vs. felt nib—what is the best use of each kind?*

A. The nylon is basically used with water-soluble ink as a writing instrument, because it has a fine tip. As such, it is an excellent lettering pen for small letters in dark colors. The felt nibs are used as applicators in both the water-base and permanent inks. These are best used for making signs or presentations, and in schools or shipping departments or anyplace where lettering must be done quickly and easily.

Q. *The inks in markers—what can you say about their composition and how do they differ?*

A. There are basically three types of inks being used in the markers today. One is the water-soluble marker, which is made with vegetable dyes and a water mixture; this is used in the fine-line markers that are meant basically as writing instruments. Some water-base markers are made in the wider nibs and are used in marker sets sold to schools, for use by children so that they cannot get the permanent ink, which is very hard to remove, on their hands, clothing, or anything else. The second type of ink is an alcohol-base ink which is also in the "permanent" family. The alcohol base combines with other dyes than the ones used in the writing-instrument or fine-line markers. The third type is a xylene or oil-base ink which is used in Dri-Mark markers; these xylene-base inks give you a much brighter shade in color than the alcohol-base inks. Another good feature about the xylene-base inks is that they will stand up to a fathometer, or sunlight, test much longer than the alcohol- or water-based inks.

Q. *How can teachers use them and which kinds are best for their use?*

A. Again, the use of the marker is determined by the type of person who is going to use them. In the lower grades, teachers should use only water-base markers because of the age of the children. The permanent ink markers are used in high school or in college for making presentations, signs, and posters or anything else that can be handled by older people.

Q. *For signs, presentations, etc., which markers are the best to be used?*

> A. We find that the permanent-ink, wide-nib markers are the best to use, because they cover a larger area and the ink capacity in that type of marker will do the job better than a fine-line marker.

Q. *What should a user know about care and use of markers?*

> A. The user should always know that a marker should be covered when not in use, because all markers are basically capillary-action markers. This means that if the cap is taken off the marker, air gets into the barrel and evaporates the ink in the container. With permanent-ink markers care should be taken that they are not accidentally used on furniture or any place that has a porous top, because it will be very, very hard to remove the ink. Otherwise, normal care in using markers is all that is necessary. Water-base markers will dry easily if left uncovered. When this occurs, submerging the marker in hot water will reactivate the ink, although the tone will be slightly lighter due to dilution of the ink.

Q. *Can you add anything that would be useful to a letterer?*

> A. Markers are made in a range of 12 to 48 colors, and by use of colors lettering can be made very attractive and can be attention-getting. As said before, the use of the markers on white board is most important because it will allow all the colors to come through. The average marker contains ink for about two hours of steady and continuous use. When used for a few minutes at a time, or with normal stop-and-go, a marker can last for days or weeks. In using any marker, do not stroke too rapidly; this can cause skipping by not allowing the ink to seep through. Several types of markers are made with interchangeable nibs and cartridges of different styles and sizes. These are convenient for the person who may require a marker on his person at all times.

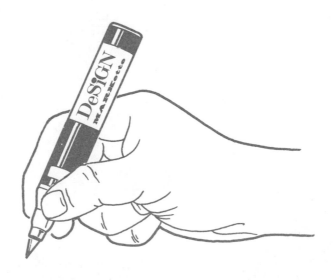

Instant Lettering: A Valuable Aid to All Who Work with Lettering

All phases of the graphic arts industry, as well as schools and nonprofessional artists, have a daily need for this new adjunct to hand lettering.

Instant lettering refers to a pressure-sensitive dry-transfer system to provide an easy and rapid method for setting repro-quality type. Letters, numerals, illustrations, symbols, and tonal effects are printed onto a plastic-base film and their back is coated with an adhesive. By use of pressure, the characters will be transposed onto almost any clean, dry surface.

The major users are advertising studios, with their need for layout work; display studios for copy on expensive displays and exhibits; signwriting shops for jobs that require a degree of finish that is usually impossible by hand; silk-screen shops for originals to be hand cut, or for photo stencils; and all the schools in the land for use in making their visual aids, signs, posters, overhead projections, etc.

The list of users is endless, and the list of products made by the manufacturers seemingly so. For our purposes here, we shall present and discuss the major products of Letraset, the leading manufacturer of instant lettering and its related products.

While the use of these products is important and essential to many people, certain restrictions must be noted. The styles, sizes and colors of the alphabets are necessarily limited to those available. However, within these limits instant lettering is a versatile aid, especially to nonprofessionals.

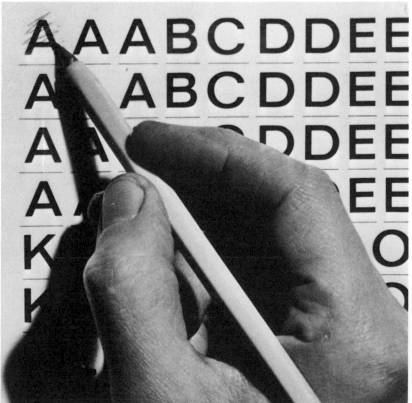

1. Remove the blue protective backing sheet and align the letter using the Spacematic® system.

Seat the letter prior to transfer. To do this, press the letter onto the work surface with your finger.

2. To transfer, use a medium ball-point pen.

Use light up-and-down strokes of the pen to transfer. The letter does not have to turn completely gray, nor do the strokes have to be extremely close together.

Do not let the sheet move during this operation and do not rub so hard that the plastic sheet bulges.

3. Tack down the top edges of the letter with strokes of the pen.

4. Anchor the sheet below the letter with your finger and peel away from the top.

Cover the completed word with the blue backing sheet and burnish down hard with your thumbnail.

It is important to press large letters firmly into contact with the art surface before transferring them.

Use a broad-ended stylus (e.g. the cap of a ball-point pen) and first shade widely over the letter, then repeat using normal shading, paying particular attention to the edges of the character.

A sampling of the over 300 type styles available in instant lettering dry transfers. There are 25 point sizes, from 6 to 288 point. All characters are available in black, and over 100 in white. Helvetica medium is available in black, white, red, blue, green, and gold. The entire range is illustrated in the Letraset catalog.

Letraset *instant lettering* — 72pt HELVETICA MEDIUM — HAAS — 717 — U S A Order No — 47-72-CN

AAAABCCDDDE;˙
EEEEEEFFGGHH;
HIIIIJKLLLLLMMN;;
NNNNNOOOOOOPP;
QRRRRRSSSSSTTT;
TTUUUUUVVWXYZ
AAAABBCCDDE;;
EEEEEEFGGGHHH
IIIIJKLLLLMMMNNN;
NOOPPPQRRRRSS;;
SSSTTTTTUUUUVW
WXYYZZ123456;
7890&?!£$ß()⁒‰⟨⟩

Each sheet is 10″ × 15″.

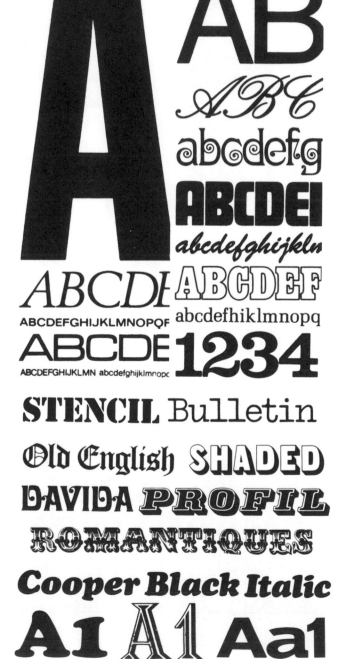

TYPE STYLES

STENCIL Bulletin

Old English SHADED

DAVIDA PROFIL

ROMANTIQUES

Cooper Black Italic

A1 A1 Aa1

176

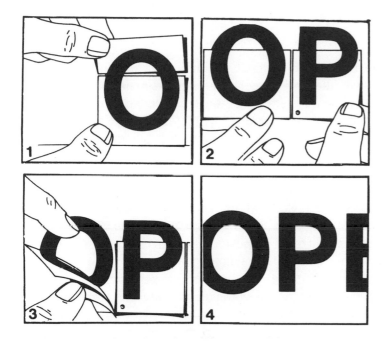

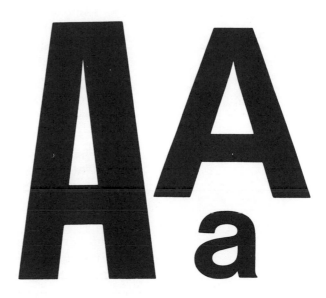

Letrasign is a vinyl self-adhesive sign system manufactured by Letraset. Letrasign incorporates a unique self-spacing system for obtaining automatic visually balanced spacing which gives functional and display signs a professional appearance.

Letrasign is suitable for interior and exterior signs, and it is used on vehicles, in buildings, and for display and exhibition purposes.

Letrasign is available in Helvetica medium and Franklin Gothic extra condensed, in black, white, and red, and in six sizes (from ⅝″ to 6″).

Health Services

Engineering Services

Switchboard

Housekeeping

Helvetica Medium
ABCDEFGHIJKLMNOPQRSTUV
WXYZ&?!;.,abcdefghijklmnopq
rstuvwxyz1234567890$()¢←

Franklin Gothic Extra Condensed
ABCDEFGHIJKLMNOPQRSTUVWXYZ&?!;.,
1234567890$()¢←

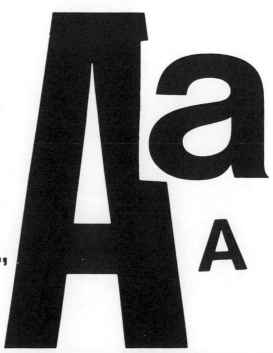

Good Lettering Without Skill: The Wrico System

Not all lettering is done by the professional. Much useful lettering can be done by almost anyone, with the proper tools and a few simple instructions. Such a tool is the Wrico Lettering System, which basically consists of specially designed mechanical or fountain pens and a set of lettering guides. It requires neither skill nor experience to use these lettering guides effectively. Each is a strip of Pyralin, with a series of openings so designed that when the point of a Wrico lettering pen is moved in contact with the sides, letters and numerals are formed. With little knowledge or skill, anyone can do accurate, uniform, and professional-looking work where neat, clean lettering is required. This is a useful tool for preparing posters, signs, visual aids for schools, libraries, churches, and stores, and other purposes.

There are limitations, of course. The lettering guides are limited in size and style of letters. The colored inks may not be used on dark surfaces since they are transparent. However, much useful work can be done with this method by amateurs and nonprofessionals.

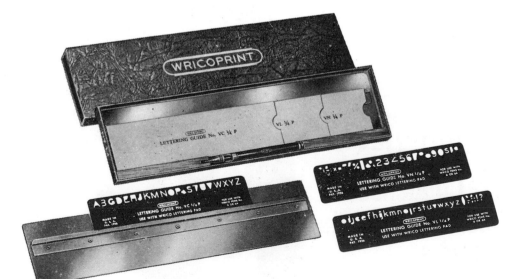

- The complete Wricoprint Lettering Set consists of:

- Lettering pen
- Steel lettering pad
- Lettering guide for capital alphabet
- Lettering guide for lowercase alphabet and punctuation
- Lettering guide for numbers and symbols

Select size, style and color you wish.

Position the guide holder — it won't slip.

Place the letter guide on holder.

Start lettering.

Admire your work!

WRICO Standard Pens are available in 6 sizes.

No. 3 No. 6
No. 4 No. 7
No. 5 No. 7T

Below are shown actual-size examples of lettering available:

ABCDEFGHIJKLMNOPQRSTUVWXYZ

abcdefghijklmnopqrstuvwxyz()"";:!?

°"+-x÷=#%[]&1234567890$¢

ABCDEFGHIJKLMNOPQ

abcdefghijklmnopqrstuvwxy

°"+-x÷=#%&1234567890$¢

ABCDEFGHIJKLM

abcdefghijklmnopq

ABCDEFGHIJ

abcdefghijklm

1234567890

ABCDEFG

abcdefghij

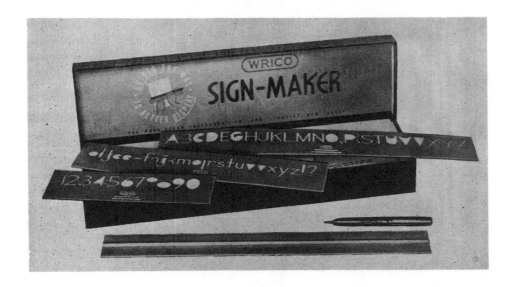

WRICO Sign-Maker Guides are used with two types of pens—WRICO Felt Pens and WRICO Brush Pens. Many customers prefer Felt Pens because of the color effects obtainable and because WRICO Felt Pen Ink dries instantly. Others prefer the Brush Pens because the India ink produces jet black lines on almost any surface.

(WRICO)

FELT PENS

Available in the seven sizes shown below with ink in seven colors.

GREEN • ORANGE
RED • BROWN • BLUE
YELLOW • BLACK

The five smallest sizes are supplied in Sets in hinge-cover plastic boxes, each set containing the Pen, 2 Ink Cartridges and extra tips.

The two largest sizes are supplied in Sets, each set containing the Pen, a bottle of WRICO Felt Pen Ink and a dropper filler.

(WRICO)

BRUSH PENS

- **EASY TO FILL**
 - **EASY TO USE**
 - **EASY TO CLEAN**

Available in the same sizes and used with the same WRICO SIGN-MAKER GUIDES as WRICO Felt Pens.

WRICO Brush Pens produce lines which are clean-cut, full and solid without excess of ink.

They are recommended for use ONLY with black India ink.

Widths of line made with WRICO Felt Pens and WRICO Brush Pens.

ABCDEFGHIJ

ABCD 23

ABCD

abcde

ABCD

AB2

AB

RA A

Shown here, actual size, are just a few styles and sizes of lettering guides available for use with WRICO FELT PENS and WRICO BRUSH PENS. Sizes range from ⅜″ to 4″ in height.

75 NEW ALPHABETS

The following hand-lettered alphabets are a cross section from the files of Lettering, Inc., one of New York's largest storehouses of photolettering styles, with over 3,000 alphabets that serve every conceivable need of anyone who may require a work of hand lettering quickly, easily, and inexpensively. These alphabets are very fine specimens of the letterer's art. Each one is imaginatively designed and superbly rendered by craftsmen who disdain the mechanical aids used by type designers and yet achieve the visual beauty and practicality of our better type faces.

These alphabets are included here with the express permission of Mr. Wilbur King, head of Lettering, Inc. They should be studied as fine examples of lettering, and used as reference material by anyone who is at all interested in widening his or her horizons in the art and craft of hand lettering.

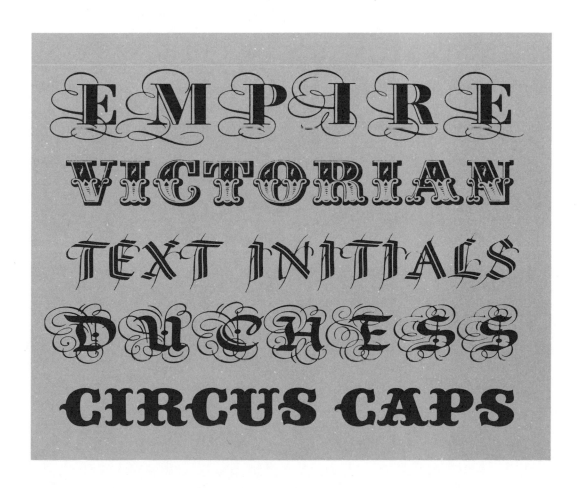

AMERICAN GOTHIC
for excellence in heading composition

aabcdefgghijkklmnopqrsttuvwxyyz
ABCDEFGGHIJKKLMMNOPQRRSTUVWXYZZ
II234566789O$¢%II23456678990

American Gothic Casual

ABCDEEFFGHIJJKKLLMNOPQRRSTTUVWXYZ
abcdeffghijjkklmnopqrrsttuvwxyyz

PHOTO-ARTLINE
for excellence in Heading Composition

ABCDEFGHIJKLMNOPQRSTUVWXYZ
abcdeffghijjklmnopqrrsttuvwxyyz
1234567890 $¢ 1234567890 $¢

DIRECTORS GOTHIC
for excellence in heading composition

aabcdeffghijjkklmnopqrrssttuvwxyyz

ABCDEFGHIJJKKLLMNOPQRRSSTTUVWXYZ

II234567890% II234567890$¢$¢

Directors Gothic Casual

Directors Gothic Casual

ABCDEFGHIJJKKLLMNOPQRRSTTUVWXYZ
abcdefffghijjkklmnopqrrstttuvwxyyz

Directors Gothic Casual

Husky
for excellence in headings

ABCDEFGHIJKLMNOPQRSTUVWXYZ
abcdefghijklmnopqrstuvwxyz

Lydian Bold

abcdefghijklmnopqrstuvwxyz
ABCDEFGHIJKLMNOPQRSTUVWXYZ

Germanic X-Light Cond.
Germanic Medium Cond.
Germanic Ultra Bold Cond.

ABCDEEEFFFFGHIJJKLLLLMNOPQRSTTTUVWXYYZ
1234456 7890

PHOTO WIDE
heading composition

ABCDEFGHIJKLMNOPQ
RRSTUVWXYZ
abcdefgghijklmnopq
rstuvwxyz
1234567890

SWISS GOTHIC
for excellence in heading composition

AABCDEFGHIJJKKKLMMN NOPQRRSTUUVVWWXXYYZ

abcdeffghijjkkklmnopqrrstttuvvwwxxyyyz

II234567890$¢%

PEIGNOT REGULAR

abcdefghijklmnopqrstuvwxyz

AVANTE GOTHIC

for excellence in headings

AVANTE GOTHIC

AAABCDEFGHIJKLMMMNOPQRSTUVVVWWWXYZ

abccdeefghijklmnopqrsttuvvvwwwxyyz

1233456789O $¢.,:;'""*!()()?£--/#%

CAACEAFRGAHTHKALLANTRRASSSTSTHUT ff ffi ffi fi fl ffl

PHOTO-STET

for excellence in headings

ABCDEFGHIJKLLMNOPQRSTTUVWXYZ

abcdefghijklmnopqrstuvwxyz

1234567890 $¢%

Gramma

PHOTO-GRAMMA
for excellence in headings

ABCDEFGHIJKLMNOPQRSTUVWXYZ
abcdefghijlmnopqrstuvwxyz

Futurama Light
Futurama Bold

ABCDEFGHIJKLLMNOPQRSTTUVWXYZ
abcdefghijklmnopqrrsttuvwxyyz

Special

ABCDEFGHIJKLLMNOPQRSTTUVWXYZ
abcdeffghijklmnopqrrstuuvwxyz

Photo-Optima

Photo-Optima

ABCDEFGHIJKLMNOPQRSTUVWXYZ
abcdefghijklmnopqrstuvwxyz

PHOTO-OTHELLO
for excellence in headings

ABCDEFGHIJJKLLMNOPQRSTUVWXYYZ
abcdefghijklmnopqrstuvwxyz

PANORAMA LIGHT
PANORAMA REGULAR

AABCDEEFGHIJKLMNOPQRSSTUVWXYZ

PHOTO-RADIAL
for excellence in heading composition

AABBCCDDEFGGHIJJKKLMMNNOOPPQQRRRSSTUUUVWWXYZ

aaaabbccddeeffgghijjkklmnooppqqrrssttuvwxyyyz

1223345567788990scc%%

Steel Outline

Steel-Semi Steel Bold

156A

Steel Shaded

AaBCDEEFFCGHIJKLMNOPPQRSTUUUVWXYZ

abcdefghijklmnopqrstuvwxyz

&.,:; $1234567890 ¢ !?'" "

193

PHOTO-COMPACT
for excellence in headings
excellence in headings

ABCDEFGHIJKLLMNOPQRS
TTUVWXYZ
abcdeffgghijklmnopqrrstuvwxyyz
1234567890 1234567890

Britannic Regul

abcdefghijklmnopqrstuvwxyz
ABCDEFGHIJKLMNOPQRSTUVWXYZ
1234567890 (&.,:;!?"-*$¢%/)

EXOTIC SOLID
EXOTIC INLINE
EXOTIC OUTLINE
EXOTIC SHADOW

AaBbCCDEeFGHIiJKKLMMNNOPQR
RSSTtUUVWWXYYZ&.,:;""!?-()*
$1234567890¢%

Fifth Avenue
for Excellence
in Headings

ABCDEFGHIJKLMNOPQRSSTUVWXYZ
aabcdeeffghijklmnopqrssstuvwxyz
1234567890$¢ 1234567890$¢

Americana

AMERICANA MEDIUM CONDENSED

ABCDEFGHIJKLMNOPQRSTUVWXYZ

abcdefghijklmnopqrstuvwxyz

Primus

for excellence in headings

ABCDEFGHIJKLMNOPQRSTUVWXYZ

abcdefghijklmnopqrstuvwxyz

1234567890 1234567890

Trooper Flair Light

ABCDEFFFGHHHITJKKKLLLMMMNNPPP

QRRRSTThUVVVWWWXXYZ

acdefhiklmnprstuvwxyz

Bodone

PHOTO-BODONE
for excellence in headings

for excellence in headings

ABCDEFGHIJKKLLMNNOOPQRRSSTTUVWWXYZ
aaabcdeffgghijkkklmn opqrrssttuvwwxyyz

Bodoni Casual *with Italic*
Bodoni Casual *with Italic*

Goudy Heavyface
AaABCDEGHJHIJKLMMNNQRSSTTUVVWWXYYZ 12345789
abcdeffghhjijkklmmnnopqrrsstuvwxyyz (&.,:;!?""")

Goudy Heavyface Swash
AABCDEFGHIJKKKLLMMMMNNNNPRRRSTUVWXY

Normande

with
Italic Swash Caps

abcdefghijklmnopqrrstuvwxyz
ABCDEFGHIJKLLMNOPQRSTTUVWXYZ
1234567890 1234567890

Latin
Casual

LATIN CASUAL
for excellence in headings

ABCDEFGHIJKLMNOPQRSTUVWXYZ
abcdefghijklmnopqrstuvwxyz

Rotondo

PHOTO-ROTONDO
for excellence in heading composition

A B C D E F G H I J K L M N O P Q R S T U V W X Y Z
a b c d e f g g h i j k l m n o p q r r s t t u v w x y y z
1 2 3 4 5 6 7 8 9 0 1 2 3 4 5 6 7 8 9 0

PHOTO-TORINO
for excellence in headings

A B C D E F G H I J K L L M M M N O P Q R S T T U V W X Y Z
a b c d e f g g h i j k l m n o p q r s t u v w x y z

for excellence in headings

SQUARE SERIF CASUAL
for excellence in headings

ABCDEFGHIJJKKLMNOPQRRSTUVWXYZ
abcdeffghijjkklmnopqrstuvwxyz

Styton Semi-Light
Styton Black

AAABCDEFGHIJKLMNOPQRSTUVWXYZ
aabcdeffghijklmnopqrstuvwxyz
1234567890$¢ 1234567890$¢

Styton Bold

CASLON ULTRA
for excellence in headings
for excellence in headings

ABCDEFGHIJKLMNOPQRSTUVWXYZ

abcdefghijklmnopqrstuvwxyz

1234567890 1234567890

CASLON UNIQUE
for excellence in headings

ABCDEFGHIJKKLMMNOPPRRSTUVWXYZ

abcdefffffiffflghijklmnopqrstuvwxyz

for Excellence

PHOTO-CONSORT
for excellence in headings

ABCDEFGHIJKLLMNOPQRRSTTUVWXYZ
aabcdeffigghijklmnopqrrstuvwxyz

TIMELY ROMAN 1
for excellence in headings

ABCDEFGHIJKLMNOPQRSTUVWXYZ
abcdefghijklmnopqrstuvwxyz

PHOTO-WINDSOR
for excellence in headings

ABCDEFGHIJKLMNOPQRSTUVWXYZ
abcdefghijklmnopqrstuvwxyz
1234567890 $¢ 1234567890 $¢

PHOTO-ALBERTUS
for excellence in headings

ABCDEFGHIJKLMMNOPQRSTUVWXYZ

abcdefghijklmnopqrrstuvwxyz

Aster Black

abcdefghijklmnopqrstuvwxyz

ABCDEFGHIJKLMNOPQRSTUVWXYZ

Plantin Bold Condensed

ABCDEFGHIJKLMNOPQRSTUVWXYZ

abcdefghijklmnopqrstuvwxyz 1234567890(&.,:;!?'"""--*$¢%/£)

Souvenir Shadow

AaBCDEeFGHIJKLLMMNNOPQRSTTUVWXYZÆŒ

AßBDEFGHIJKLLMNPRSTUVWXY

abcdefghijklmnopqrstuvwxyz æœ hmnrs

as good as it looks

ABCDEFGHIJKLMN
OPQRSTUVWXYZ
abcdefgghijklmnoopq
rstuvwxyyz 123456789

Photo-Typewriter 8

ABCDEEFFGHIJKLL
MNOPQQRRRSTTUVWXYZ
aabbcddeffffgghhijkkll
mnopqrrrrssstttuvwxyz
1234567890$¢

Finesse
for excellence in headings

ABCDEFGHIJKLM NOPQRSTUVWXYZ
abcdefghijklmnopqrstuvwxyz
1234567789O$¢1234567789O$¢

PHOTO-GARAMON
for excellence in headings

ABBCCDEFFGHIJJKLLMN
OPPQRRSTTUVWXYZ
abcdefffghijklrnnopqrstuvwxyz

for excellence in headings

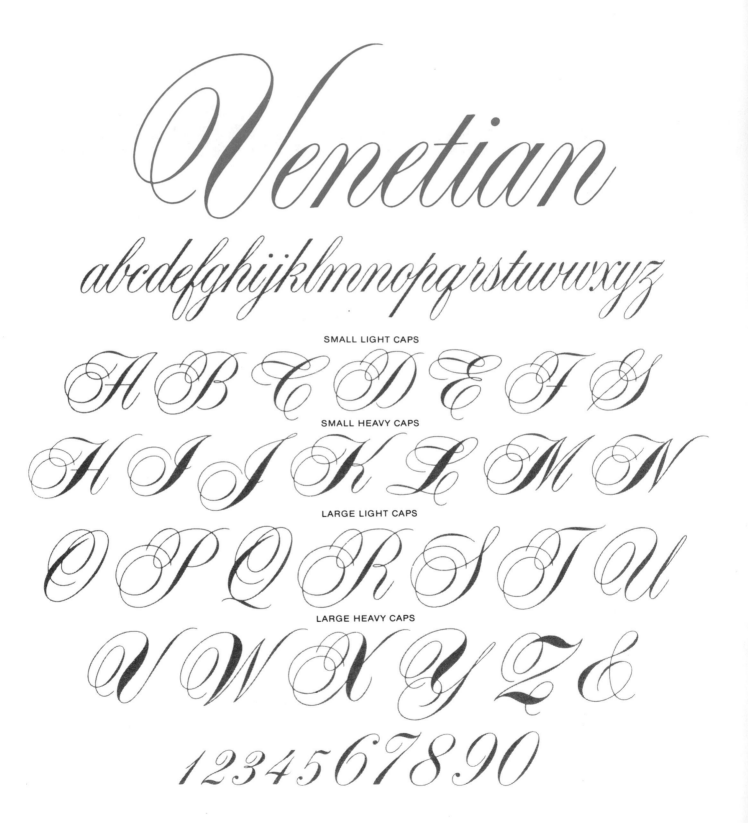

Venetian

abcdefghijklmnopqrstuvwxyz

SMALL LIGHT CAPS

A B C D E F G

SMALL HEAVY CAPS

H I J K L M N

LARGE LIGHT CAPS

O P Q R S T U

LARGE HEAVY CAPS

V W X Y Z &

1234567890

Brush Script

abcdefghijklmnopqrsstuvwxyzz

AABCDEEFGHЯIJKLLMMNNOPQRSSTUUVWXYYZ

AABCDEEFGGHЯIJKLLMM
NNOOPQRSSTTUUVWXYYZ
1234567890 1234567890 $¢

Brush Script 18 Medium

Lettering Inc Brush Script 21

Lettering Inc Brush Script 28

Lettering Inc Brush Script 15

Brush 1 Demi

AAABBCCDDEEFFGGHHIIJJKK
LLMMNNOOPPQQRRSSSTTTUUVVWWXXYYZZ
abbccddeeffgghhiijjkllmmnnoooppqrrrsstttuuuvvvwwxxyyzz

Brush 5 Medium

Brush 9 Light

Lettering Inc Brush Style 43

Lettering Inc Brush Style 38

Lettering Inc Brush Style 39

Blackjack

ABCDEFGHIJKLMNOPQRSTUVWXYZ&&
abcdefghijklmnopqrstuvwxyz

Chipper

ABCDEFGHIJKLMNOPQRSTUVWXYZ&

abcdefghijklmnopqrstuvwxyz

SOUTACHE

ABCDEFGHIJKLMNOPQRSTUVWXYZ&

$1234567890¢

COMPUTER

ABCDEFGHIJKLMN
OPQRSTUVWXYZ&

DAVIDA BOLD

AABCDEEFFGHIJKLMNOPQRSTUVWXYZ
112233445566778899OO $$¢%

PHOTO HARVEY

ABCDEFGHIJKLMNOPQRSTUVWXYZ
1234567890 1234567890

Spiral

ABCDEFGGHIIJKL
MMNOPQRSSTUU
YYVWXYYZ&
aabcdefgghijkklmnop
qrssttuvwxyz $c..:;'!!?
()/% 1234455677890

Smoke

ABCDEFGHIJKLMNOPQRSTUVWXYZ
abcdefghijklmnopqrstuvwxyz

MARVEL BOLD

FOR EXCELLENCE IN HEADINGS

ABCDEFGHIJKLMNOPQRSTUVWXYZ

AABDEFGHJILMMNPQRRSTUUVWXYY

Photo-Neal

ABCDEFGHIJKLMNOPQRSTUVWXYZ

abcdefghijklmnopqrstuvwxyz

1234567890$¢%£

HEFTY SLANT

ABCDEFGHIJKLMN

OPQRSTUVWXYZ&

()/$1234567890?!